50 ART MOVEMENTS
YOU SHOULD KNOW
FROM IMPRESSIONISM TO PERFORMANCE ART

Rosalind Ormiston

50 ART MOVEMENTS
YOU SHOULD KNOW

FROM IMPRESSIONISM TO PERFORMANCE ART

PRESTEL

Munich · London · New York

Introduction 11

50 Art Movements You Should Know

INTRODUCTION

Today, a new painting or sculpture that is monumental in size suggests that it may be destined for a gallery or museum, or the spacious home of a rich collector; an artist has the freedom to choose what he or she will produce, from its dimensions and materials to how it will be displayed. That freedom of choice is an accepted part of Western art today, but in early 19th-century France a strict code of *genre* (types of art) in painting was enforced: from its highest form, history painting, the only genre that allowed nudes and a monumental scale, to portraits, scenes from everyday life, landscapes, animal paintings, down to the lowest genre: 'still life'. To sell a work, and make a name, an artist needed exposure in the official academy exhibitions of work, and the genre system needed to be followed with little room to manoeuvre.

One artist's challenge to this tradition inspired a move by artists to break away from academic disciplines and official exhibitions, unwittingly creating a visible movement for realism in art. In 1849, French artist Gustave Courbet (1819–1877) decided to paint a monumental canvas. He chose to depict his local community at the funeral of his uncle in *A Burial at Ornans* (1849–50). The ordinariness of the subject, portrayed realistically on a vast canvas, signalled a challenge to the genre hierarchy and the officialdom of the Salon, the annual art exhibition of the Académie des Beaux-Arts in Paris. Courbet focused on 'realism', real life, not the more popular style of Romanticism. His 'realism' in this painting and others links to the social realist paintings by fellow artist Jean-François Millet (1814–1875) and the socio-economic graphic art of Honoré Daumier (1808–1879), all practising a new art form that defined a new movement: Realism.

In Paris in 1863, many painters found their progressive art to be unacceptable to the Salon, prompting an outcry that led to the formation of the Salon des Refusés for the outcasts, who were growing in number. It spurred new paintings, more independent gallery shows, more groups of artists united in their desire for change, and a force spreading across northern Europe into

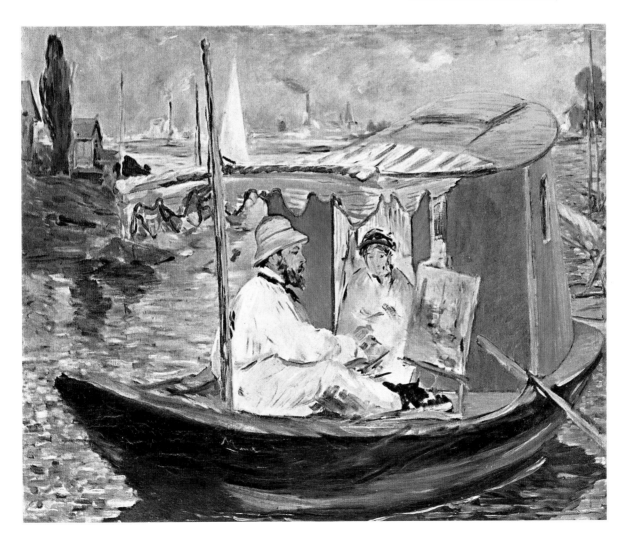

Édouard Manet, **Monet Working on His Boat,**
1874, oil on canvas, 82.5 x 105 cm
Neue Pinakothek, Munich, Germany

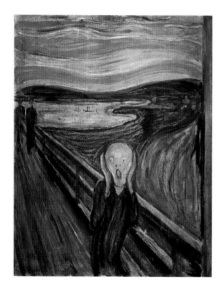

Edvard Munch, **The Scream,** 1893, oil,
tempera and pastel on cardboard,
91 x 73.5 cm
Nasjonalgalleriet, Oslo, Norway

Russia. In Paris the 'Impressionists', a derogatory term coined
by an art critic for a group of independent professionals, created
paintings very much in the spirit of modern city life, exhibiting
them together from 1874 until 1886. Artists were able to line the
banks of the Seine to paint *en plein air*, thanks to the availablity of
portable easels and, since 1841, pure paint in small metal tubes.
This enabled them to capture the pleasure of the moment,
especially outdoors, as seen in *Monet Working on His Boat* (1874),
a portrait of painter Claude Monet (1840–1926) by Édouard Manet
(1832–1883). It placed the Impressionist art movement firmly at the
centre of Parisian art, with more to follow in Seurat's Pointillism,
Redon's Symbolism and *fin-de-siècle* Art Nouveau, visible in the
art of Henri de Toulouse-Lautrec and Alphonse Mucha, who
socialised together in the nightlife of Montmartre. These
developments broke the academy's hold and made it possible
for new art movements to flourish. This, in turn, gave artists new
freedom, which did not, however, guarantee sales of their work.
Vincent van Gogh sold only one painting during his entire life.

Groups of artists painting in a new form were often characterised
by a term coined by art critics in a review. Such terms – whether
derogatory or complimentary – were used to describe their work.
For the artists in question, these labels identified them and their
work and can therefore be regarded as a positive development. In
the wake of these new terms came art movements, as was the case
with Impressionism, Pointillism and Les Fauves. Travelling art
exhibitions and artists spread the new forms of art, widening the
circle of interest in other countries. For artists who worked alone,
such as Vincent van Gogh and Paul Cézanne, a label could create
an umbrella term, such as Post-Impressionism, created by
English artist and art critic Roger Fry. Sometimes, a generic term
was used to identify avant-garde trends such as Art Nouveau,
demonstrably a decorative art, and Art Deco.

The lead-up to the 20th century was replete with art movements
– Realism, Impressionism, Pointillism, Symbolism, Art Nouveau –

filled with a galaxy of artists revered today but often castigated for their modernity in their own lifetime. It is worth stopping to consider not only the art movements of the past, but also those that confront us today in the 21st century. Is it art? Yes it is.

By the early 20th century artists were taking further control, and issued manifestos to explain the aesthetic of their art at the birth of a new movement, like Futurism, Vorticism, Suprematism and Dada, to name but a few. Artists were literate. They read Sigmund Freud (1856-1939), C. G. Jung (1875-1961) and Immanuel Kant (1724-1804), and their minds exploded with the possibilities of transferring the written word to visual expressions of psychological theories. Reading the history of each art movement, one can see how closely it relates to what artists were witness to at the time: social deprivation or excess, political domination or freedom, cultural values and commercial considerations. Major calamities, the 1914–18 World War in Europe and the 1917 Revolution in Russia, informed the art of the second decade of the 20th century. During the war the temperature of art changed; artists who had served as soldiers drew on their horrifying experiences for their art. The Expressionist movement that began to emerge before the war, as seen in Edvard Munch's versions of *The Scream* (1893–1901), anticipated the way Expressionist artists would explore the cathartic subject matter of their paintings as a means of coping with the aftermath of war.

Late 19th and 20th-century art movements identified progressive art forms and the artists who instigated change, or challenges, or rejected the art of their time. However, many artists – from Marcel Duchamp (1887–1968) and Pablo Picasso (1881–1973) to Louise Bourgeois (1911–2010), Joseph Beuys (1921–86), Gerhard Richter (b.1932), Damien Hirst (b. 1965) and Matthew Barney (b. 1967) – defy group identity and cannot be defined solely by an art movement, for theirs is an art created in a particular way without thought for current or future trends,and more often creating the trend itself. After the French painter Paul Cézanne (1839–1906) had exhibited with the Impressionists from 1874 to 1877, he left Paris to concentrate on

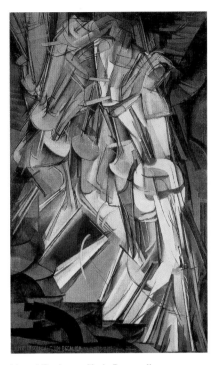

Marcel Duchamp, **Nude Descending a Staircase,** No.2, 1912, oil on cardboard on panel, 95.9 x 60.3 cm
Philadelphia Museum of Art, Pennsylvania, PA, USA

his personal interpretation of art. He is linked to Post-Impressionism and Neo-Impressionism and is regarded as the 'Father of Modern Art' and forefather of Cubism. He would probably be surprised to know that his art spawned the Cubist art movement and placed him in high esteem in the arts world. Russian artist Wassily Kandinsky (1866–1944), who is associated with many avant-garde movements, including Suprematism, Constructivism and his own movement, *Der Blaue Reiter* (The Blue Rider) with its challenging manifesto, stands out primarily as an originator of abstract art, lyrical in its compositions, painterly, colourful and, in his own view, spiritual – as exemplified in *Composition No. 7* (1913).

The Spanish artist Pablo Picasso (1881–1973), who moved to Paris and became interested in the primitive art of Africa and Oceania, experimented with masks in his paintings. One of them, *Les Demoiselles d'Avignon*, painted in 1907 and initially shown only to friends at his studio, is now counted as a key work of Primitivism, yet its composition also identifies Picasso's interest in the geometric formulations of Cézanne's art, emerging as Cubism. Thus some art forms, such as *Art Informel* in Europe and Abstract Expressionism in America, do take on the qualities and composition of more than one art movement.

In 1913 a historic occurrence altered transatlantic views of contemporary art and its art movements. The Armory Show of 1913, held at the Armory building on New York's Lexington Avenue and officially known as the International Exhibition of Modern Art, advertised an exhibition of 'American and foreign Art'. The foreign art included work by Edgar Degas, Paul Cézanne, Odilon Redon, Claude Monet, Georges Seurat, Vincent van Gogh, Henri Matisse, Constantin Brancusi, Marcel Duchamp and Alexander Archipenko – artists associated in Europe with Impressionism, Symbolism, Pointillism, Fauvism, Post-Impressionism, Futurism, Primitivism and Cubism. French artist Marcel Duchamp, exhibiting his Cubo-Futurist painting *Nude Descending a Staircase, No. 2* (1912), which was reviled by some art critics and called 'an explosion in a shingle

Wassily Kandinsky, **Composition No. 7,** 1913, oil on canvas, 200 x 300 cm
Tretyakov State Gallery, Moscow, Russia

factory', and marginalised alongside other works, embraced the difference of opinion and continued to create new art, such as his series of 'readymades'. Matisse's *Blue Nude (Souvenir of Biskra)* of 1907, criticised for its 'leering effrontery', shocked American visitors yet firmly established contemporary European art movements in America.

At this time in New York, a group of artists led by Robert Henri (1865–1929) and later to be labelled the 'Ashcan' group for their gritty depictions of city life were engrossed in Realism, without interest in Abstraction. *McSorley's Bar* (1912) by John Sloan (1871–1951) depicts

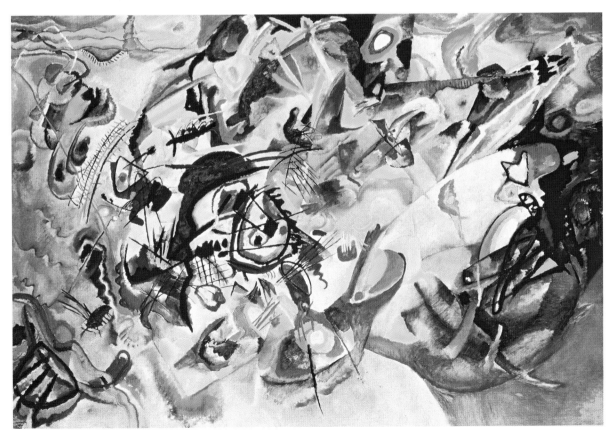

a real bar, the oldest 'Irish' ale house in New York, still in existence today with an interior that the artist would recognise. Realism in art in America continued unabated through the century, surfacing most dramatically in Photorealism from the 1970s onwards. In the 1920s artists like Georgia O'Keeffe and Stuart Davis began defining American Modernism through their experimentation with new art forms in different mediums. It would take the rise of Nazism in Germany in 1933 to flood America with some of the most talented artists from Europe. This led to the establishment of the New York School in the 1940s and the explosion of Abstract Expressionism, Pop Art and Color Field painting, and causing the centre of the arts world to shift from Paris to New York.

In the aftermath of World War I, which left populations finding it hard to come to terms with loss, deprivation and a return to order, the Surrealist movement explored the perception of reality. Belgian artist René Magritte (1898–1976) did this with gentle, thought-provoking humour, as, for example, in *The Treachery of Images (This Is Not a Pipe)* (1929). In post-war Germany, by contrast, the rise to power of the Nazi Party in 1933 led to the denunciation of modern art, and the artists who created it, as 'degenerate' – with a ban on sales of modern art unless it was figurative or heroic in content. Modern art was removed from galleries and museums, and in 1937 hundreds of such works went on display at the *Entartete Kunst* (Degenerate Art) exhibition in Munich, drawing a record number of visitors, many of whom had never before experienced modern art. The modernist, avant-garde art movements of Germany were condemned, forcing artists who had previously flourished there to flee abroad, especially to America.

'Lowbrow' art, which surfaced in California in the late 1960s, is identified with custom-car culture and the illustrated pages of 'underground comix'. Today, however, one of the leading exponents of the genre, Robert Williams (b. 1943), is also one of the highest paid artists of his generation. The surreal fantasy world of the American artist and illustrator is in demand, but Williams has

never pushed for entry into the arts world; he was successful before the mass media became interested in him, first coming to widespread attention through an album cover for Guns N' Roses in 1987. Identification of 'Lowbrow' art as a movement has, nevertheless, given recognition to the many other artists who continue within its remit today.

The growing movement of Performance Art, a personal experience performed in front of a camera or an audience, needs publicity in order to expand the dialogue between artist and audience. From the 1960s onwards Performance Art was recognised as a movement: the original, complex performances of the incomparable German artist Joseph Beuys (1921–1986) firmly established its avant-garde credentials, and the sensational performances of American artist and musician Laurie Anderson (b. 1947) confirmed its place. Once established, its capability is in the hands of the artist, such as the shocking 'Action' performances of the Viennese Action Group. American artist Cindy Sherman (b. 1954), who performs to camera and is recorded in photographs, takes on the roles of countless people, from film stars, as in *Untitled* (*As Marilyn Monroe*) (1987), to anonymous typecasts. Her extraordinary art continues to remain original.

If asked, few artists would relish a label, preferring instead to be recognised for their work alone. The history of art movements, however, shows that such labels, often coined by art critics to classify an incipient movement, can help groups of artists to challenge tradition. Today it is noticeable that art dealers, publicists and the engagement of the artist with the media are near-essential to establish an artistic presence. In the 1990s a group of former students from London University's Goldsmiths college staged several exhibitions and happenings. Their art was consistently bought by the collector Charles Saatchi (b. 1943) for his gallery in north London to exhibit his purchases of the newest art and to promote the presence of this young group through public exposure to their art. His collection of work by young British artists led to their

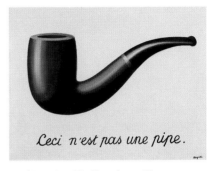

René Magritte, **The Treachery of Images: Ceci n'est pas une pipe,** 1929, oil on canvas, 60 x 81 cm
Los Angeles County Museum of Art, CA, USA

Richard Hamilton, **Just what is it today that makes homes so different, so appealing?,** 1956, collage, 26 x 23.5 cm
Kunsthalle, Tübingen, Germany

name tag, YBAs, not so much a movement as an aesthetic for new thinking, at times shock delivery, and original explorations of new art forms, such as *House* (1993) by Rachel Whiteread (b. 1963), a cast sculpture of the interior of a house in Mile End, east London, just prior to demolition. It was the most extraordinarily original sculpture, and focused public attention on the artist and the YBA 'movement'. Group success culminated in the *Sensation* exhibition of 1997, which firmly established the artists, including their leader, Damien Hirst, Sarah Lucas, and Jake and Dinos Chapman. The exhibition appealed greatly to a younger age group, some of whom were visiting a gallery for the first time to see an overwhelmingly successful show and the last British art movement of the 20th century.

At the same time, in East Germany, with the fall of the Berlin Wall at the end of 1989, the art of the New Leipzig School revealed a group of figurative painters, headed by Neo Rauch, leader of an unknown movement in figurative art that posed a challenge to Minimalism, Conceptual Art and the YBAs. It created a new frisson of activity in the auction houses, major galleries and the studios of emerging artists waiting in the wings to create the next art movement. And if there is one thing that unites the global arts community it is the differing opinions on art, and art movements. Art historians pore over artists' letters, journals, news reports and exhibition catalogues to seek out which artist was the first to paint, draw, sculpt or perform art differently to what had gone before. These discussions will continue as long as new research discovers unsourced papers, or paintings hidden in attics or gallery stores. It is what makes art such an interesting subject to read about, learn about and, most of all, visually enjoy.

The 21st century brings with it the expectation of new art movements, even if it is harder for artists to be original, to create an art movement that does not reflect a past movement, be it Realism or Abstraction or Minimalism. The accreditation of graffiti as an art form that is also sold in auction houses, notably the

work of the British artist Banksy (probably b. 1975), lends solidity to an art form that refuses to be labelled or tied down by capitalist interest. Confirmation of Street Art graffiti as a growing art movement – one that stretches back to the 1960s and is described by Banksy as the most honest form of art today – is appreciated by the public, regardless of the fact that most of it is created at night when the street lights are out. An understanding of the aesthetic underlying distinctive art movements widens the enjoyment of looking at and experiencing art. From the 1850s to the present day, it is worth knowing key moments that led artists to try a new form of artistic expression, often culminating in a specific art movement that is intrinsically linked to the social, cultural and political climate of the day.

Cindy Sherman, **Untitled (As Marilyn Monroe)**, 1982, colour photography, 39.2 x 23.2 cm Museum of Fine Arts, Houston, Texas, USA

50 ART MOVEMENTS

From the late 1840s onwards

Inspired by the large-scale canvases of 17th-century Dutch painters such as Rembrandt van Rijn (1606–1669), French artist Gustave Courbet (1819–1877) began in 1849 to paint his first monumental work, *A Burial at Ornans* (1849–50), also titled *a Painting of Human Figures, the History of a Burial at Ornans*. The location was Courbet's own village of Ornans, in eastern France. The painting depicted a large gathering of ordinary members of the community, including the clergy and the artist's mother and sister, attending the funeral of Courbet's great-uncle. It was a factual representation of contemporary life in rural France, which Courbet painted with life-size figures.

Those who viewed the painting on display at the annual Salon in Paris in 1850 disliked what they saw, finding it trivial and ugly – a critical reaction to the aggrandisement in scale and subject of ordinary people in a genre reserved for royalty or history painting. The people's uprising in the revolution of 1848 was still fresh in the minds of the establishment. It had triggered the same reaction to the realism of Courbet's *The Stone Breakers* (1849), which depicted a young man and an older man in servitude, breaking rocks along the roadside, the reality of the lives of members of the poorer class. Both works brought notoriety to Courbet and prompted younger artists to shift away from idealised romanticism towards painting contemporary life. Courbet called it 'the debut of my principles'. *The Bathers*, shown at the 1853 Paris Salon, also shocked, for Courbet's naked bathers were real, not mythical women. His pavilion outside the Universal Exposition in Paris in 1855 was called The Pavilion of Realism, showing 40 of his paintings, including *The Artist's Studio* (1854–55), subtitled 'A Real Allegory'. Jean-François Millet (1814–1875), exhibiting at the same time as Courbet, used realism in his works of peasant life – *The Sower* (1850), *The Gleaners* (1857), *The Angelus* (1859) – but these are emotional depictions of poverty, unlike Courbet's matter-of-fact realism.

Exhibited in 1865, French artist Édouard Manet (1832–1883) interpreted the realism of contemporary life in *Olympia* (1863), causing scandal with his version of Titian's *Venus of Urbino* (1538). Manet's 'Venus' was a naked Parisian prostitute staring directly at the bourgeoisie spectators. It earned Manet the title of the 'first modern painter'.

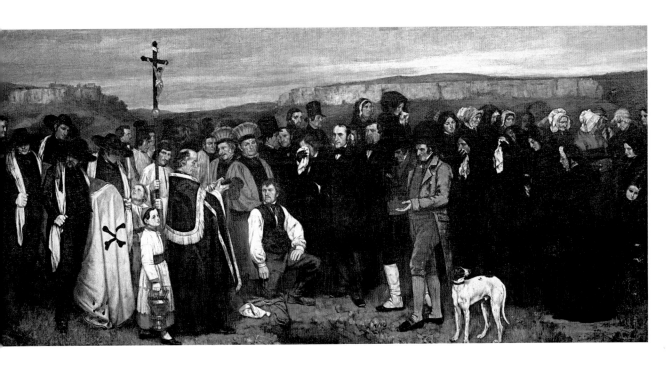

Gustave Courbet, **A Burial at Ornans,** 1849–50, oil on canvas, 315 x 668 cm
Musee d'Orsay, Paris, France

Last third of the 19th century

Gustave Courbet's break with art genre tradition inspired artists to free themselves from academic tradition, experiment with new ideas and put on their own exhibitions independent of the official Paris Salon. In Paris the modernisation of the city in the 1850s, instigated by Napoleon III (1808–1873) and carried out under the direction of Baron Georges-Eugène Haussmann (1809–1891), saw the sweeping away of medieval parts of the city to create new public parks, wider boulevards, and new architecture – inspiring painters to capture the modernity of city life both in its effervescence and loneliness. The extension of railway lines to the Parisian suburbs allowed day trips to the city's outskirts. Both Édouard Manet's *Monet Working on His Boat* (1874) and *Summer's Day* (1879) by Berthe Morisot capture the spontaneity of the artists' lives through painting *en plein air*, outdoor impressions of what they saw and experienced. New, industrially manufactured paints in vivid colours such as chrome yellow and emerald widened the creative span for colour and allowed freedom of movement; the small metal tubes were portable and long-lasting, enabling artists to paint on location. Pierre-Auguste Renoir, who displayed his

art at the first 'Impressionist' exhibition (not a name the group had used), stated that without paint in tubes there would have been no 'impressionist' painters.

The first Impressionist exhibition – held at 35 Boulevard des Capucines, Paris, the former studio of the photographer Nadar, from 15 April to 15 May, 1874 – was an independent art show by 30 artists putting up 165 works for sale. The group included Claude Monet (1840–1926), Pierre-Auguste Renoir (1841–1919), Berthe Morisot (1841–1895), Paul Cézanne (1839–1906), Alfred Sisley (1839–1899), Edgar Degas (1834–1917) and Camille Pissarro (1830–1903). They called their collective 'The Anonymous Society of Painters, Sculptors, Engravers, etc.' The term 'impressionists' was coined by a French art critic, Louis Leroy. In a scathing review ('The Exhibition of the Impressionists') published in the satirical newspaper *Le Charivari* on 25 April 1874, he used the term to disparage the style of the paintings on show. Having borrowed the word from the title of one of the works, *Impression: Sunrise* (1872) by Claude Monet, Leroy attacked the artists as 'painters of mere impressions'. Eight Impressionist exhibitions were held between 1874 and 1886.

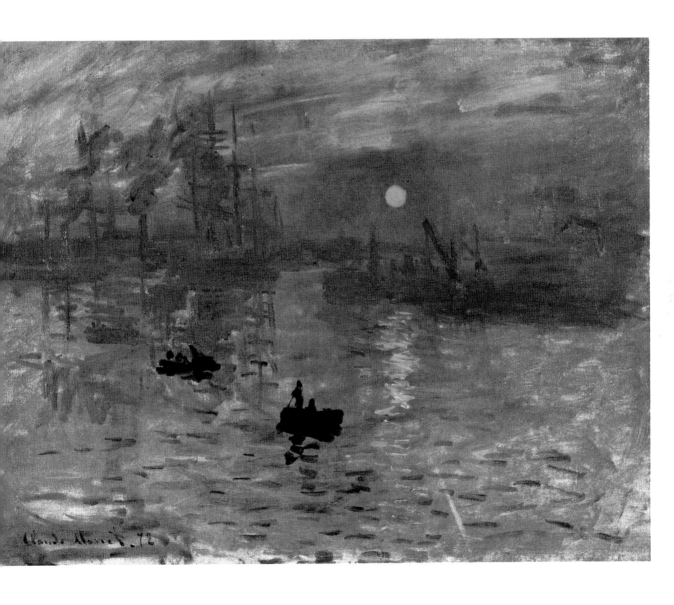

Claude Monet, **Impression: Sunrise**, 1872, oil on canvas, 48 x 63 cm
Musée Marmottan Monet, Paris, France

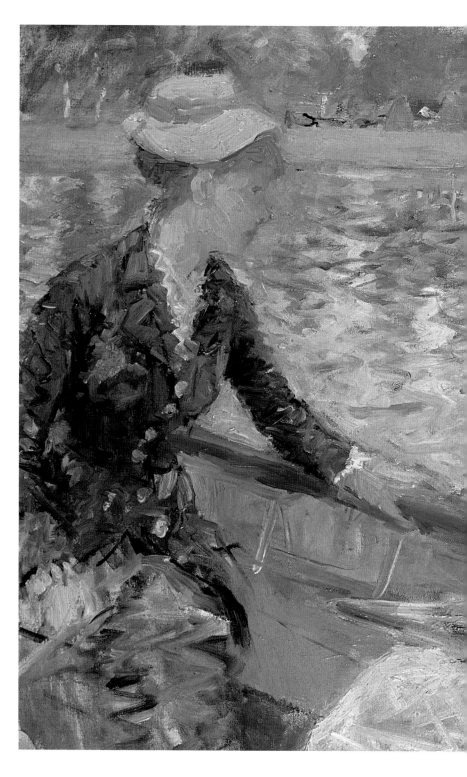

Berthe Morisot, **Summer's Day**,
1879, oil on canvas, 45.7 x 75,2 cm
National Gallery, London, England

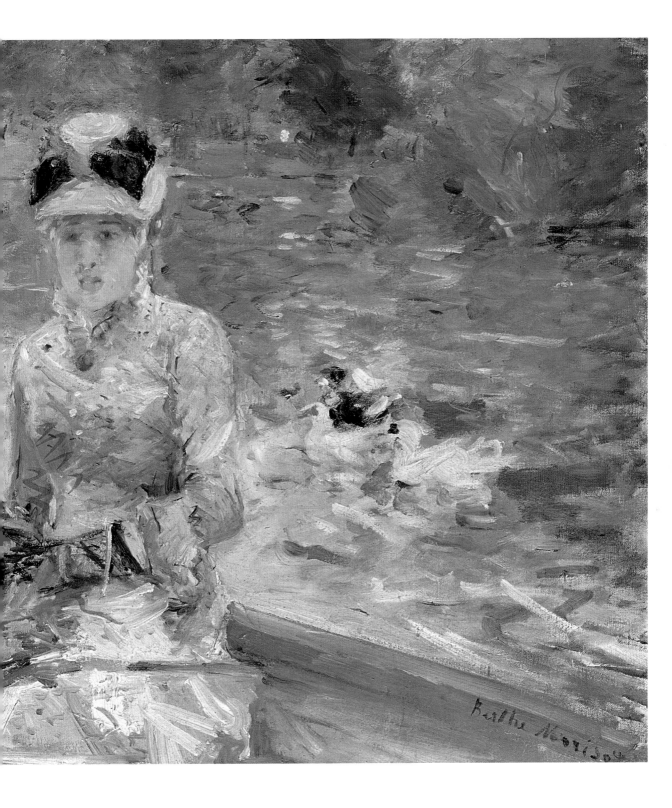

POINTILLISM

c.1886–1910

Pointillism is dated to the creation of a large-scale oil-on-canvas painting, *Sunday Afternoon on the Island of La Grande Jatte* (1884–86), which the French artist Georges Seurat (1859–1891) exhibited in 1886 at the final Impressionist exhibition in Paris. The painting depicts the Parisian bourgeoisie enjoying a pleasant afternoon on the banks of the Seine. The scene was typical of the 'Impressionist' painters, capturing the essence of a moment in time through colour and light. What set this painting apart was Seurat's use of a different technique, one based on a scientific approach to colour theory.

Drawing on the colour theory expounded by the French chemist Michel-Eugène Chevreul (1786–1889), Seurat applied simultaneous contrasts and complementary colours in his work, juxtaposing thousands of tiny dots of pure paint pigment. When viewed from a distance, these blurred in the spectator's eye into a harmonious blend of light, shade and colour harmony. The same effect can be seen in another Seurat masterpiece, *The Circus* (1890–91). The science of colour theory was popular among artists and included reading American physicist Ogden Rood (1831–

1902), whose *Modern Chromatics, with Applications to Art and Industry* (1879) divided colour into purity, luminosity and hue; the work was translated into French and German in the 1880s. Seurat's method was defined by the art critic Félix Fénélon as 'peinture au point' – effectively Pointillism.

Discussion of complementary colour separation, using line and colour to create emotional expression, was published in *Cercle Chromatique* (1889) by Charles Henry (1859–1926). Paintings using this theory were referred to by art critics as chromo-luminarism, 'Divisionism' and 'Neo-Impressionism'. Artist Paul Signac (1863–1935) embraced Seurat's methodology and worked with him to develop it, as seen in *Cassis. Cap Cànàille* (1889; private collection). Both Seurat and Signac preferred the term 'Divisionism'. Exhibition of *Sunday Afternoon on the Island of La Grande Jatte* at the Salon des XX in Brussels in 1887 spread interest in Pointillism, notably in the art of Théo van Rysselberghe (1862–1926). In 1899 Signac published *From Delacroix to Neo-Impressionism*. Seurat's use of complementary colour led to the expressive art of Fauvism.

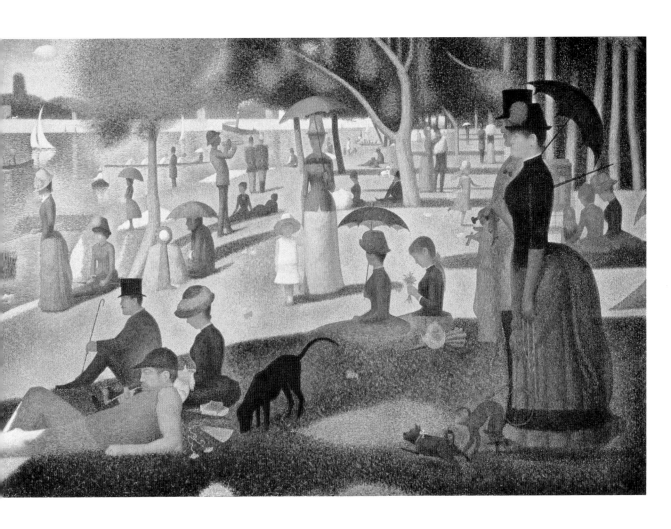

Georges Seurat, **Sunday Afternoon on the Island of La Grande Jatte**, 1884–86, oil on canvas, 207.5 x 308 cm
The Art Institute of Chicago, Illinois, USA

4

POST-IMPRESSIONISM

c.1880–1905

The term 'Post-Impressionism' was invented by English artist and art critic Roger Fry (1866–1934) for the title of an exhibition, *Manet and the Post-Impressionists*, held at the Grafton Galleries in London from 8 November 1910 until 15 January 1911. It resulted from his search for an expression to define the work of a group of artists who had moved on from Impressionism in about 1888. Fry had travelled to Paris to visit art dealers, to persuade them to lend artworks for the show; French dealers wanted to sell to the British market, and many of the artists Fry chose had not been exhibited in England. On display were paintings by 27 artists and sculptors showing 155 paintings – 41 by Paul Gauguin; 22 by Vincent van Gogh, including *Wheatfield with Crows* (1890); and 21 by Paul Cézanne, including *Bathers* (1898–1905) – plus 50 drawings, and more than 20 bronze or ceramic objects. Artists represented included Édouard Manet, Gauguin, Cézanne, Van Gogh, Othon Friesz, Henri Matisse, Pablo Picasso, Paul Signac, Odilon Redon and Georges Seurat.

In the 38-page, unillustrated catalogue, Fry explained his views: 'The pictures collected together in the present exhibition are the work of a group of artists who cannot be defined by any single term ... Yet their own connection with Impressionism is extremely close.' He added that the 'Post-Impressionists' were concerned not with painting the impression of light, but in expressing emotion through colour. The exhibition received very harsh reviews from art critics but created interest among British art collectors, who embraced Post-Impressionist art at a time when many of the artists on display were dead. In his retrospective analysis Fry highlighted the changes that had taken place in French art from circa 1888 to 1905, a period in which artists such as Cézanne developed their own style. His *Still Life with Plaster Cupid* (1894), with its variation of perspective, pointed to forthcoming radical changes in art.

In the catalogue to the second Post-Impressionism exhibition, held in 1912, Fry stated that the artists' work showed that they wanted to create form not imitate it. Since that time the term 'Post-Impressionism' has been adopted to represent the paintings of artists after the last Impressionist exhibition in 1886 up until 1905.

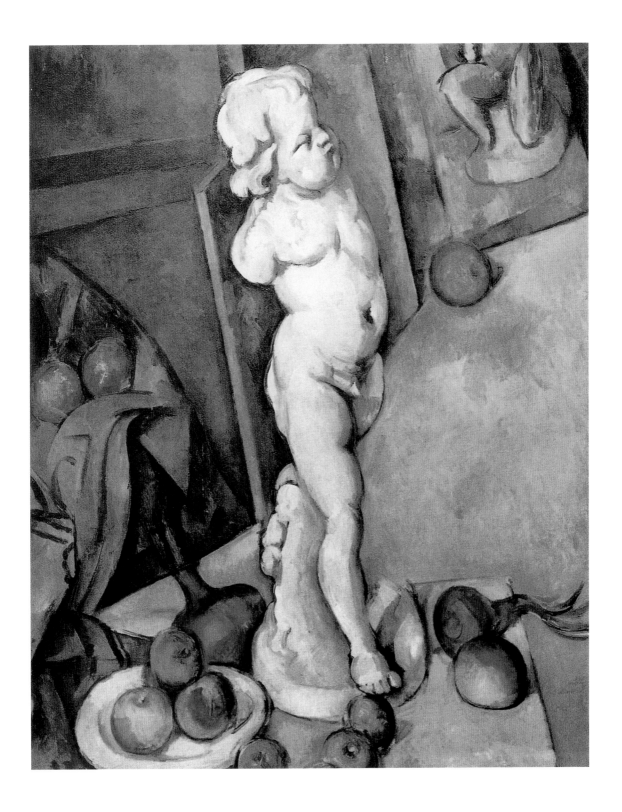

Paul Cézanne, **Still Life with Plaster Cupid**, 1894, oil on paper on board, 70.6 x 57.3 cm
The Courtauld Gallery, London, England

SYMBOLISM

In France in the 1880s a literary group opposing 'warts and all' realism in literature was linked to a loose group of artists whose art could be seen as a counter-reaction to Realism and Impressionism. They were collectively known as Symbolists. Their aim was to portray not the everyday but a transmutation of the real world – to capture the mystical and imaginary, the allegorical, spiritual and mysterious, to create fantasy, and to link the real with the spiritual, a reflection of the inner self, not the outer reality.

The Symbolist Manifesto of 1886, created by the Greek poet Jean Moréas (1856–1910), a member of the French literary Symbolist movement, rejected the realism of writer Émile Zola's (1840–1902) cycle of 20 contemporary novels *Les Rougon-Macquart*. Writing in the publication *L'Événement* in 1886, Symbolist poet Gustave Kahn explained: 'We are tired of the everyday, the near-at-hand and the contemporaneous; we wish to place the development of the symbol in any period, even in dreams (dreams being indistinguishable from life) ...'

The Symbolist poets urged painters to embrace the mystical, to reveal other-worldliness, the occult, unseen but sensuously felt sensations. Symbolists favoured writer Joris-Karl Huysmans (1848–1907) and the self-absorbed, decadent aesthete Des Esseintes in Huysmans's 1884 novel *À Rebours* (Against Nature), which included descriptions of Gustave Moreau's (1826–1898) *The Dance of Salome* and *The Apparition (Dance of Salome)*, both created in 1876 and exhibited at the Paris Salon that year.

In the 1880s Paul Gauguin, Émile Bernard (1868–1941) and others formed a Symbolist group in Pont-Aven, Brittany. Gauguin painted *The Vision after the Sermon (Jacob Wrestling with the angel)*, (1888; National Gallery of Scotland, Edinburgh), which is considered to be his first Symbolist work. Norwegian artist Edvard Munch was impressed by the work of Gauguin and Vincent van Gogh's use of colour, as reflected in his lurid, emotional painting *The Scream* (1893). Symbolism in art flourished in France and Belgium, and was linked to the visually expressive *fin de siècle* culture of Art Nouveau. The artists associated with Symbolism were led by Bernard, Pierre Puvis de Chavannes (1824–1898), Odilon Redon (1840–1916), Gustave Moreau and Belgian artist Fernand Khnopff (1858–1921).

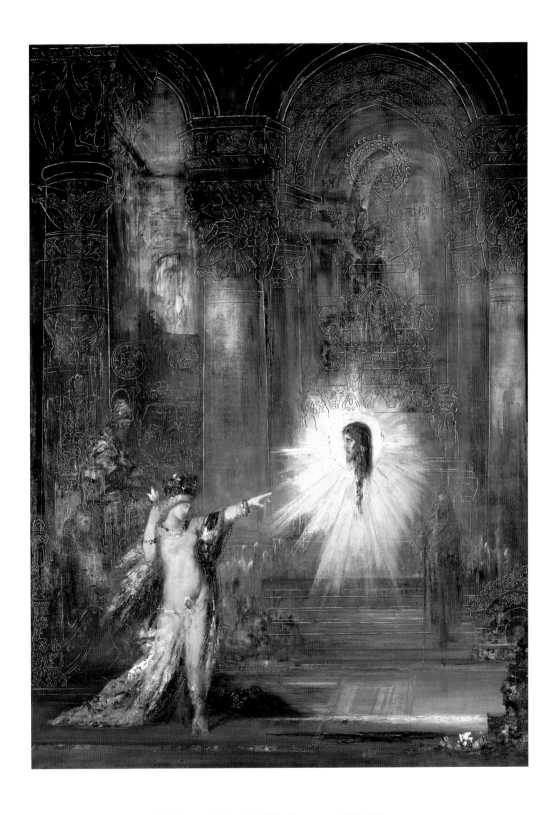

Gustave Moreau, **The Apparition (Dance of Salome)**, 1876, oil on canvas, 142 x 103 cm
Musée Gustave Moreau, Paris, France

c.1890–1910

The beginnings of *fin de siècle* Art Nouveau (New Art) – also known in France as *Art Moderne* and *Stile Liberty* (after the decorative stock in Liberty's department store in London), and as *Jugendstil* in Germany, *stile Floreale* in Italy, as well as the 'whiplash', 'macaroni' or 'noodle' style, to name but a few – can be dated to the late 1850s, particularly in Paris, Brussels and London, and peaked between 1890 and 1910. It was a movement that influenced art, architecture, decorative art, graphic design and typography across Europe and America, and was well established by the time the World's Fair opened in Paris in 1900. With its organic, swirling lines, the Art Nouveau style dominated the fair and is visible to this day in the entrances to the Paris Metro, created by the French architect-designer Hector Guimard (1867–1942). The poster *La Maison Moderne*, circa 1902, by Manuel Orazi (1860–1934) exemplifies the 'new art'.

Art Nouveau was a contemporary style without reference to historicism. Its characteristics are loosely divided into two styles: first, the curving, sinuous lines associated with Arthur Heygate Mackmurdo (1851–1942) in London, who founded the Century Guild and was inspired by the arts and crafts aesthetic of artist-designer William Morris; the decorative art of Émile Gallé, working in Nancy, France; the American designer of stained glass and decorative art Louis Comfort Tiffany (1848–1933); and artists Jules Cheret (1836–1932), J.A.M. Whistler (1834–1903), Aubrey Beardsley (1872–1898) and Moravian artist Alphonse Mucha (1860–1939); secondly, the linear designs of architect-designers Charles Rennie Mackintosh (1868–1928), Josef Hoffmann (1870–1956) and Koloman Moser (1868–1918). Although not a collective group of artists, they were all influenced by Japanese art and design.

The Hamburg-born art dealer Siegfried Bing (1838–1905) is credited with influencing the 'new art' through Japanese imports sold in his shop in Paris, where he lived from 1854 on. His second shop, called Maison de l'Art Nouveau, opened in 1895 and sold modern objets d'art. Japan had reopened its trade routes to the West in 1854 and imports from there were in high demand. Works by Japanese artists Katsushika Hokusai (1760–1849), Utagawa Hiroshige (1797–1858) and Kitagawa Utamaro (1753–1806) influenced artists seeking to break ties with Western art tradition.

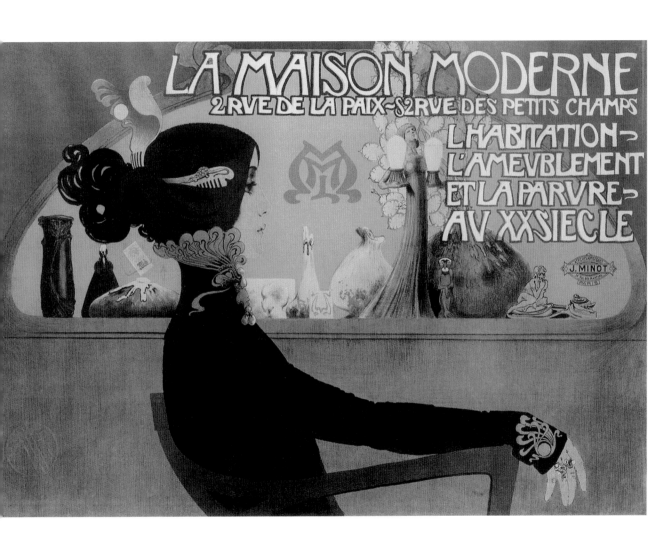

Manuel Orazi, **La Maison Moderne**, c.1902, poster
Private collection

EXPRESSIONISM

Expressionism defines the German artists' groups *Die Brücke* (The Bridge), formed in Dresden in 1905 by four architecture students: Ernst Ludwig Kirchner (1880–1938), Fritz Bleyl (1880–1966), Erich Heckel (1883–1970) and Karl Schmidt-Rottluff (1884–1976), and *Der Blaue Reiter* (The Blue Rider), formed in 1911 by Russian artist Wassily Kandinsky (1866–1944) and German-born artist Franz Marc (1880–1916).

The aim of the four founders of *Die Brücke* was to break with the tradition of academic art. Kirchner was excited by the exhibition of Neo-Impressionist art held in Munich in 1904. Combined with an interest in Gothic woodcuts, primitive and Oceanic art, and influenced by Norwegian artist Edvard Munch (1863–1944), he sought to create art that was expressive in form and colour. His *Girl under a Japanese Parasol* (1906–09; Kunstsammlung Nordrhein-Westfalen, Düsseldorf, Germany) is representative of Expressionism in its use of loose brush strokes, and colour that abandons naturalism in favour of emotion, an expression of the subject as the artist's personal vision. Associated with *Die Brücke* is German Expressionist Emil Nolde (1867–1956), who was invited to join the group after its members saw an exhibition of his work in 1906.

In 1911 Kandinsky, Marc and other artists resigned from the *Neue Künstlervereinigung München* (New Artists' Association Munich), founded in 1909, over its disinclination to accept Kandinsky's move towards abstraction. They launched a new group, *Der Blaue Reiter*. The 'First Exhibition by the Editors of the *Blaue Reiter*' was held from 18 December 1911 until January 1912 (and then travelled throughout Germany). A second exhibition, showing drawings, watercolours and printed graphics, was held in March 1912. The first edition of Kandinsky and Marc's almanac, *Der Blaue Reiter*, appeared in 1912 in an edition of 1,200. It was funded by a relative of the artist August Macke, the art collector Bernhard Koehler. Other followers of this German Expressionist group were Gabriele Münter, Lyonel Feininger, Marianne von Werefkin, Albert Bloch and Alexei von Jawlensky.

Occasionally, a movement is informed by the work of an artist not associated with the group. A case in point is the influence exerted on the Expressionists by the remarkable portfolio of Käthe Kollwitz (1867–1945).

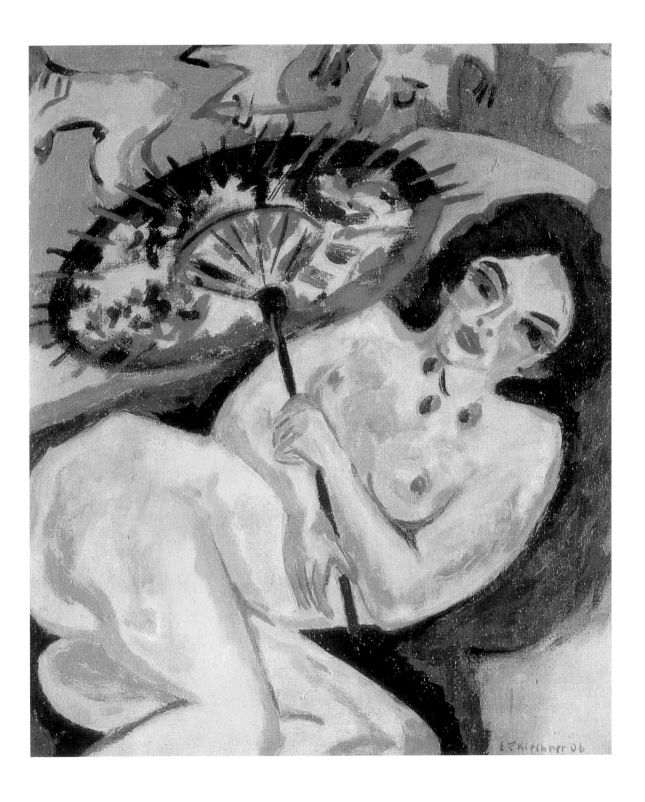

Ernst Ludwig Kirchner, **Girl under a Japanese Parasol**, *c.*1906–09, oil on canvas, 92.5 x 80.5 cm
Kunstsammlung Nordrhein-Westfalen, Dusseldorf, Germany

FAUVISM

c.1898–1910

In his review of the 1905 Salon d'Automne in Paris, in the *Gil Blas* newspaper, art critic Louis Vauxcelles summed up the paintings of Henri Matisse and his circle as the work of *'fauves'* (wild beasts) – a term that lent distinction to the group and gave it its name.

Vauxcelles's analytical view of the originality of their art, both bold and extreme in its 'piercing clarity', defined the decorative, non-naturalistic colour, crude brushwork and innovative application. His review pushed Henri Matisse (1869–1954), André Derain (1880–1954) and Maurice de Vlaminck (1876–1958) further into the public eye, and for Vauxcelles, Matisse was *'le fauve des fauves'*. Other critical views that likened their works to childlike daubs served only to increase public interest in them.

Matisse was tutored at the École des Beaux-Arts in Paris by Gustave Moreau, whose advice to his students was to 'express yourself' in art. His words link artists who crossed boundaries between Neo-Impressionism, Expressionism and Fauvism. Some critics saw Fauvist art as childlike naivety in its approach to painting with parts of the canvas unfinished, a two-dimensional space, the use of bright colours galvanising the senses.

Viewers can feel the heat in Matisse's *Luxe, Calme et Volupté* (1904–05), inspired by Charles Baudelaire's poem 'L'invitation au Voyage' from *Fleurs du Mal* (1857). De Vlaminck's *Woman and Dog* (1906; private collection) and Matisse's *Woman with a Hat* (1905) express the exuberant, colourful nature of Fauvist art, which releases the inhibited into a world of freedom, gaiety and frivolity. The spectator may see elements of Primitivism, Symbolism and Expressionism in their works, and Fauvism does link the three without intention, through the use of nudity, strong colours, and two-dimensional figures and forms – the aim being the essence of the subject rather than its exact image.

Art of this period is closely linked to its literature. Artists in the city and in village communes, such as Derain and de Vlaminck, read Friedrich Nietzsche (1844–1900) and followed his radical thinking. The critics of the day read Nietzsche, too, and drew parallels between the new art and his theories. In retrospect historians have looked for links to political affiliations, a form of anti-establishment anarchy, but this would have been on an individual basis, not a group tendency.

Maurice de Vlaminck, **Woman and Dog**, 1906, oil on canvas, 73 x 60 cm
Private collection

Henri Matisse, **Luxe, calme et volupté**, 1904–05, oil on canvas, 98 x 118 cm
Musée d'Orsay, Paris, France

CUBISM

c.1907–1925

The history of Cubism is inextricably linked to the visit by Pablo Picasso (1881–1973) and Georges Braque (1882–1963) to Paul Cézanne's retrospective of 56 paintings at the Paris Salon d'Automne of 1907, a year after his death. Cézanne (1839–1906) had shown at the 1873 and 1877 Impressionism exhibitions. What was important to Cézanne was not painting an impression of the visual but capturing the essence of it through constant study. He painted the same landscapes and still life many times, 'The eye is not enough, reflection is needed', he stated. His still lifes in particular show a regularity of form: the rim of a vase or glass, the roundness of fruit, the shape of dishes, revealing solid rectangles, spheres, oblongs that balance the objects even though perspective is distorted. The viewpoint of the spectator is at the same time above the objects, parallel to them and below them.

In a letter to artist Émile Bernard (1868–1907) dated 15 April 1904 and published in 1907, Cézanne partly revealed his method: '... treat nature by the cylinder, the sphere, and the cone, everything in proper perspective so that each side of an object or plane is directed towards a central point ...'

In a later letter he said: 'We must render the image of what we see, forgetting everything that existed before us ...'

Inspired by Cézanne's paintings. Picasso and Braque worked towards his theory. The exploration of a geometric, cuboid form with facetted planes is visible in Picasso's *Les Demoiselles d'Avignon* (1907), shown in his studio to friends but not exhibited until 1916. Here one can also see elements of Primitivism, in the mask-shaped heads and in the bodies similar to those in Cézanne's much copied *Bathers* series – such as *Les Grandes Baigneuses* (1900–06), where the geometric diagonals break up the surface. Braque also experimented, copying Cézanne's cubic formations in his *Houses at L'Estaque* (1908) and *Le Portugais* (1911). Interest in 'cubism' spread; the Spanish artist Juan Gris (1887–1927) developed it, as did Jean Metzinger (1883–1956), Fernand Léger (1881–1955) and Marcel Duchamp (1887–1968).

The name Cubism was perhaps created by the art critic Louis Vauxcelles. Writing in the newspaper *Gil Blas* (14 November 1908) on a Braque exhibition, he described what he saw in the paintings as 'little cubes' and 'cubic bizarreries'.

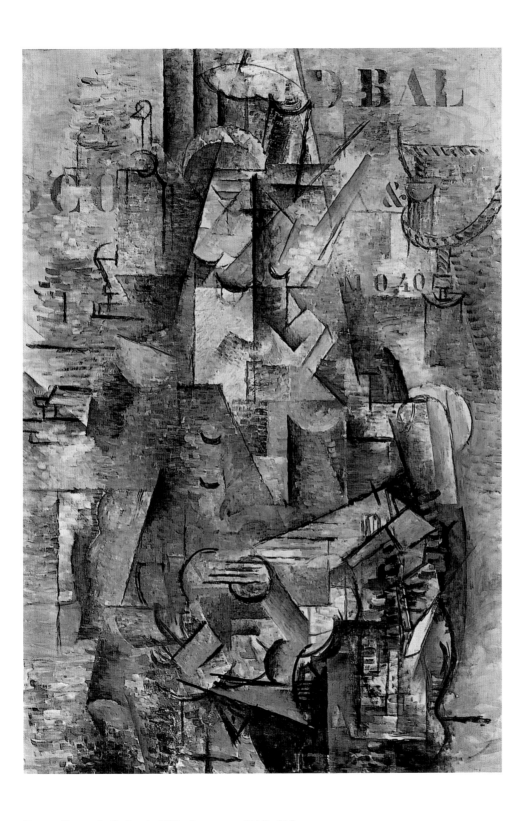

Georges Braque, **Le Portugais**, 1911, oil on canvas, 116.5 x 81.5 cm
Kunstmuseum, Basel, Switzerland

1912/13

Orphism, a spin-off of Cubism – also referred to as Colour Cubism or Orphic Cubism – was the inspiration of a group of French artists in Paris around 1912. Following his interest in the mathematical proportions of the 'golden section', sculptor Jacques Villon, founder member of the Groupe de Puteaux, and the Section d'Or, experimented with simultaneous contrasts. He highlighted the concept of Orphism in the magazine Section d'Or, in 1912. An exhibition of the same name was held at the Galerie de la Boétie, Paris, the same year. The Orphists were led by Robert Delaunay (1885–1941), his wife, Sonia (1885–1979), and Villon. Other Orphists included Fernand Léger (1881–1955), Francis Picabia (1879–1953), Marcel Duchamp (1887–1968), and his brother Raymond Duchamp-Villon (1876–1918). At its simplest, Orphism infused the monochrome tones of Cubism with a saturation of colour, whereby the object remained secondary to it. The term was coined by Guillaume Apollinaire to describe their 'pure painting', a rhythmic pattern of colour not found in the analytical, intellectual cubism of Georges Braque (1882–1963) and Pablo Picasso (1881–1973).

The Delaunays were immersed in the use of pure colour, Robert in painting, Sonia in painting, textiles and theatrical costumes. Her watercolour Prose of the Trans-Siberian and of Little Joan of France (1913) illustrated the story of a journey by the poet Blaise Cendrars; art and prose were combined in colour flooding through the text across the page. Delaunay's 'orphic' swirls move the eye down the page. It was called the first 'simultaneous' book. Robert and Sonia Delaunay's experimentation with colour prisms, fragmented in their Simultaneous Contrasts and solar disc series, was central to their theories on colour and form, producing abstract compositions. Robert Delaunay's Eiffel Tower paintings introduced a fourth dimension: time. Fernand Léger promoted Orphism through an alternative visual sensation, utilising line and colour. In his series Contrast of Forms (1913) the volumetric tubular, square and cylindrical shapes represent the human form in semi-abstract depictions. Orphism spread throughout Europe, notably in Russia, where, under the label Rayonism and influenced by Robert Delaunay, Natalia Goncharova (1881–1962) developed her own vision.

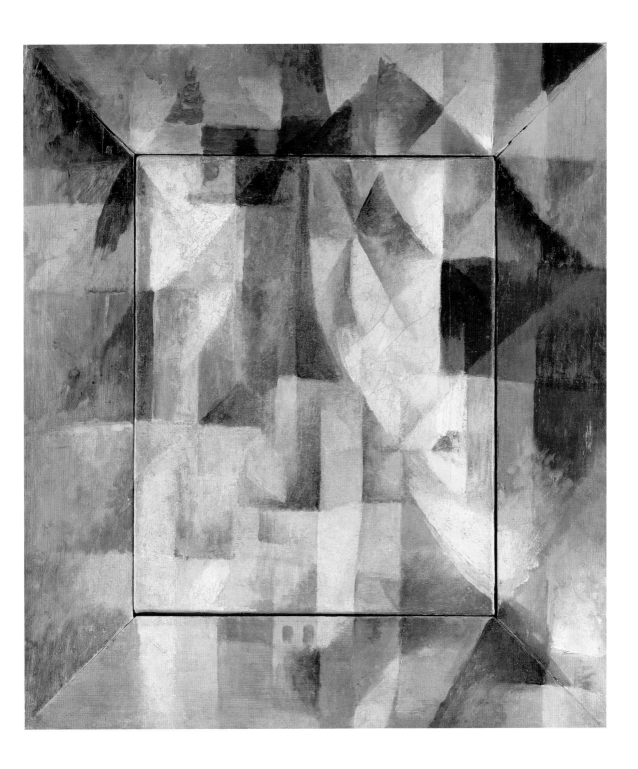

Robert Delaunay, **Simultaneous Windows on the City**, 1912, oil on canvas, 55.2 × 46.3 cm
Hamburger Kunsthalle, Germany

FUTURISM

The birth of Futurism can be dated to the Futurist Manifesto published on the front page of the French newspaper *Le Figaro* on 20 February 1909 by its founder, the Italian poet and writer Filippo Tommaso Marinetti (1876–1944). The manifesto laid out the principles of his movement, which embraced art, architecture, literature, poetry, craft, theatre, sound and music. It highlighted 11 main points, which railed against the art of the past. Futurists wanted to demolish museums and libraries and all the art of past centuries, claiming that to glorify war was 'the only cure for the world'. Futurism also embraced danger, aggression and new technology, and accentuated a love of speeding cars and aeroplanes: '… a roaring motor car that seems to run on machine-gun fire is more beautiful than the *Victory of Samothrace*', Marinetti stated. 'Art + Action + Life = Futurism.' Further manifestos followed, such as the 'Manifesto of Futurist Painters', circulated in Marinetti's publication *Poesia* (11 February 1910). Addressed 'To the Young Artists of Italy', it asked followers to reject the art of Italy's ancient and Renaissance past, and to see the country not as a vast Pompeii of ancient history but as a new country, reborn.

Alongside Marinetti – born in Egypt – the leading members of the radical group, all Italians, were painter and sculptor Umberto Boccioni (1882–1916), painter Carlo Carrà (1881–1966), painter and composer Luigi Russolo (1885–1947) and painter Gino Severini (1883–1966). Art and literature focused on modernity and speed, notably in Boccioni's painting *The City Rises* (1910–11), which captures the dynamism of the city; the essence of speed also informs his sculpture *Unique Forms of Continuity in Space* (1913).

The widening Futurist group included young architects rejecting classicism and all forms of past architecture to create modern buildings. Antonio Sant'Elia (1888–1916), a key member, is noted for his visionary insight of future architecture. His ideals were cut short by his early death in 1916. Sant'Elia's design aesthetic, as outlined in the *Manifesto of Futurist Architecture* of 1914, was carried forward after World War I by Virgilio Marchi (1895–1960). The onset of war in 1914 dissolved the Futurists' ambitions. Although many members of the group moved on to other ventures after the war, Futurism remained a visible art form until the beginning of World War II.

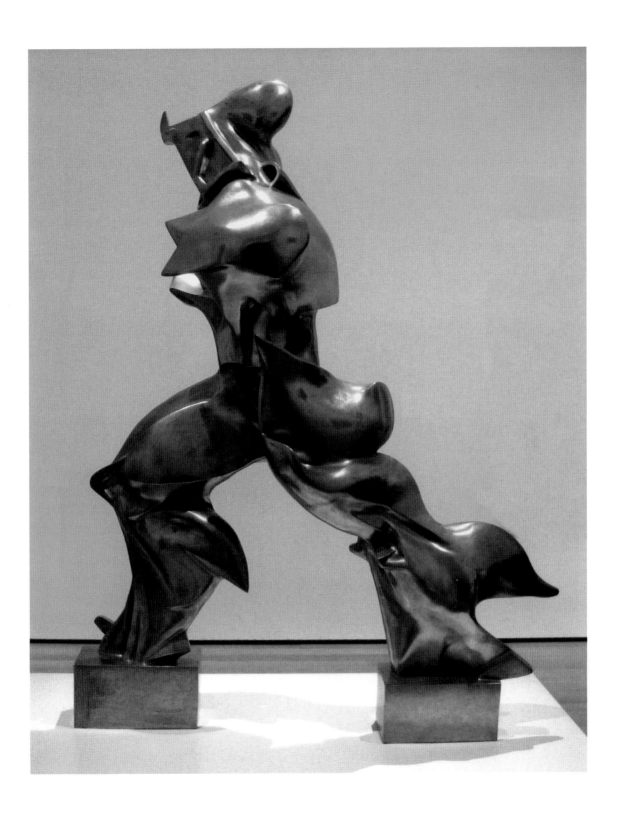

Umberto Boccioni, **Unique Forms of Continuity in Space**, 1913 (cast 1931), bronze, height 111.4 cm
Museum of Modern Art, New York City, NY, USA

SUPREMATISM

1915–
early 1930s

The Russian art movement Suprematism is indelibly associated with its originator, Kiev-born artist Kasimir Malevich (1878–1935), a proponent of 'non-objective art'. A prolific writer on art, he formally launched the Suprematist movement in the capital, Petrograd, in 1915, during the exhibition *0.10 – The Last Exhibition of Futurist Painting*, alongside a Suprematist manifesto. Included in the displays of art were 36 geometric-abstract paintings by Malevich, dating from 1913–15. One of them, *Black Square*, stood for his movement's theories on art; it was, according to Malevich, 'the face of the new art ... the first step of pure creation in art'. *The Basic Suprematist Element: The Square* (1913), a black square on a white background, was key to his Suprematist theory of total abstraction: an exploration of the absence of the object. Malevich constructed his ideology on the square, a non-naturalistic shape formed of geometric lines, as in *Black Square*, around 1920. His theoretical writings place the line, the square and related geometric forms as central to Suprematism.

The beginnings of Suprematism emerged in the costume and set designs Malevich created for the Cubo-Futurist opera *Victory over the Sun*, performed in 1913 in what was then still St Petersburg. In 1915 Malevich published *From Cubism and Futurism to Suprematism: The New Realism in Painting* to affirm the progression towards Suprematism. Artists who joined his group, known as *Supremus*, included Aleksandra Ekster (1882–1949), El Lissitsky (1890–1941), Liubov Popova (1889–1924) and Olga Rozanova (1886–1918).

Malevich identified three phases of Suprematism: from the black square and its economy of form, a fifth dimension, to a second phase of coloured forms, predominantly red, to signify revolution, as seen in *Suprematist Painting, Eight Red Rectangles* (1915), followed by the white Suprematist phase, representative of abstract purity – 'pure action', highlighted in *Suprematist Composition: White Square on White* (1918), with the tilted white square lightly pencilled on a white background perhaps illustrating a final move towards infinity and Malevich's pronouncement that 'works of art are manifestations of the superconscious [subconscious] mind'. By 1920 Malevich had announced the death of easel painting and, in 1922, the end of Suprematism, which its followers nevertheless continued to practise.

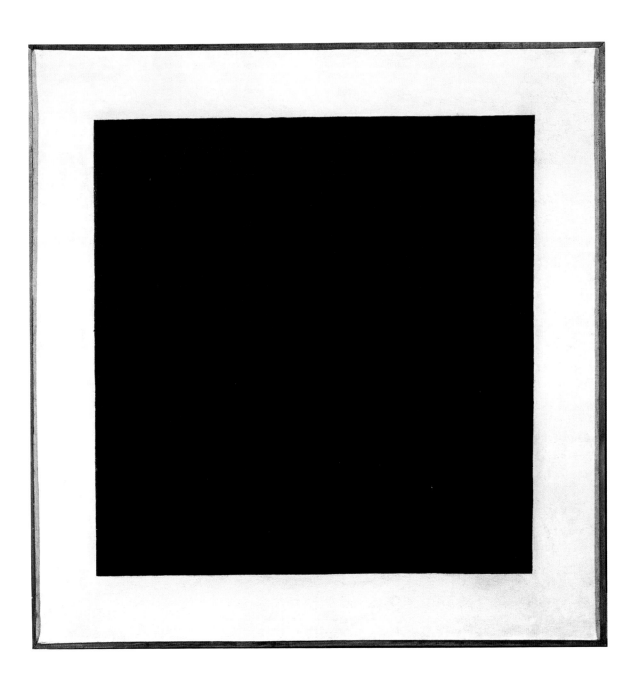

Kasimir Malevich, **Black Square**, *c.*1920, oil on canvas, 53.5 x 53.5 cm
The Russian Museum, St Petersburg, Russia

DADAISM

The name Dada was probably chosen at random from a German-French dictionary on 8 February 1916 to provide a name for an 'anti-art' movement that had been launched by a group of poets and artists living in Zurich, some of whom had fled to Switzerland during World War I. This coincidental selection of the name emphasised the element of chance, a core ingredient of the group's aesthetic. The Dada movement was led by Tristan Tzara (1896–1963), a Romanian poet and writer, along with fellow Romanian Marcel Janco (1895–1984), who had gone to Zurich to study architecture, Richard Huelsenbeck (1892–1974), a German poet, and Hugo Ball (1886–1927), a German dramaturge and author.

Hugo Ball had moved to Zurich in May 1915 with Emmy Hennings, a cabaret singer, who became his wife in 1920. On 5 February 1916 they opened a 'literary' nightclub, Cabaret *Voltaire*, the venue for a Dada 'cabaret' of poetry readings, music and performances. Ball, the chief proponent of Dada at this time, decorated the club with art by Dada members. In art the Dadaists favoured collage and montage.

The underlying aim of the group was to protest against the atrocities of the war and to draw attention to its tragedy through the group's own absurd actions, all aimed at undermining authority in the form of comic nihilism. Swiss netrality allowed the group to perform plays and shows, to publish manifestos, plays, books and articles, and to create art under the name Dada without fear of reprisals. Other group members included the German painter and film-maker Hans Richter (1888–1976), the French poet, novelist and art critic Guillaume Apollinaire (1880–1918), the Alsatian artist and writer Hans Arp (1886–1966), who had moved to Zurich in 1915, the Swiss artist Sophie Taeuber (1889–1943), who became Arp's wife in 1922, and Francis Picabia (1879–1953), a French painter and a pioneer of Dada in Paris in 1917.

In June 1916 *Cabaret Voltaire*, the Dada group's first publication, was printed in Zurich in German and French by Julius Heuberger. It was edited by Hugo Ball, with contributions from many artists, including Pablo Picasso (1881–1973), Wassily Kandinsky (1886–1944) and Amedeo Modigliani (1884–1920). And in 1918 Tristan Tzara published the *Dada Manifesto* to sum up the group's idealism and ambitions.

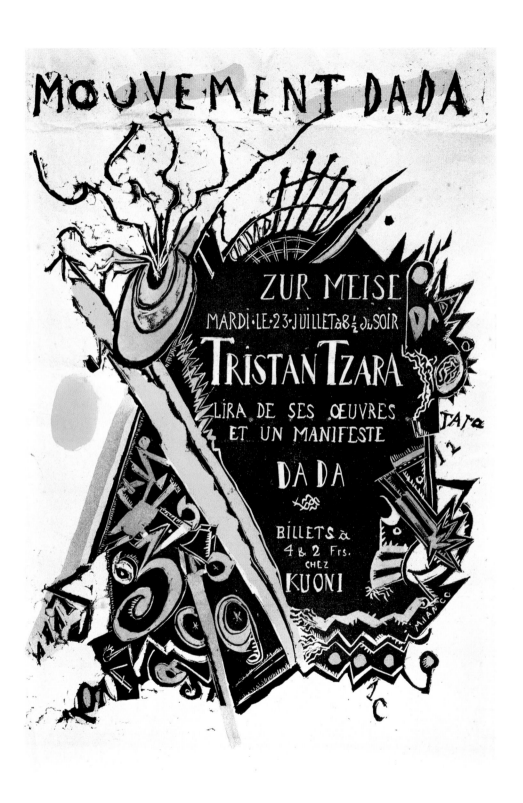

Marcel Janco, **Mouvement Dada**, poster, advertising a poetry reading by Tristan Tzara, 1918, linocut and watercolour
Private collection

1924–c.1945

One can see the first stirrings of Surrealism as early as 1900, following the publication in November 1899 of *The Interpretation of Dreams*, in which Sigmund Freud (1856–1939) explored the relationship between dreams and reality. Widely read by artists, it informed the Surrealists' work, as can be seen in the dreamlike, subconscious quality of their art.

A black-and-white group photograph taken around 1920 by the American photographer Man Ray (1890–1976) includes major names of the Surrealist movement in Paris: Tristan Tzara (1896–1963), Paul Éluard (1895–1952), André Breton (1896–1966), Hans Arp (1887–1966), Salvador Dalí (1904–1989), Yves Tanguy (1900–1955), Max Ernst (1891–1976) and René Crevel (1900–1935). The Belgian artist René Magritte (1898–1967) is also closely associated with Surrealism.

Artists such as Hans Arp and Marcel Duchamp were involved in Dadaism as much as Surrealism and there are related areas that cross over, both in literary and artistic fields. Surrealism emerged from Dada, and from Constructivism, in its random-word poetry and spontaneous drawing. The Surrealists

experimented with automatism in art, poetry and writing. The movement was officially launched in 1924 when the French writer André Breton, who had been trained in medicine and psychoanalysis, published *The Manifesto of Surrealism*. A definition was included: SURREALISM, *n*. Psychic automatism in its pure state, by which one proposes to express – verbally, by means of the written word, or in any other manner – the actual functioning of thought. Dictated by the thought, in the absence of any control exercised by reason, exempt from any aesthetic or moral concern.

To summarise Surrealism, Breton chose a phrase written by Comte de Lautréamont (1846–1870): 'As beautiful as the chance encounter of a sewing machine and an umbrella on an operating table'. Dalí created drawings and paintings based on this theme but it was the unconscious experience of such a possibility that informed the paintings, sculpture and theoretical writing of the group. Magritte captured the essence of Surrealism with humour in *The Treachery of Images (This Is Not a Pipe)* (1929), and *The Rape* (1934).

René Magritte, **The Rape,** 1934, oil on canvas, 73 x 54 cm
Menil Collection, Houston, Texas, USA

Salvador Dalí, **The Persistence of Memory,** 1931, oil and tempera on panel, 24.1 x 33 cm
The Museum of Modern Art, New York City, NY, USA

CONSTRUCTIVISM

The Constructivist movement is associated with Marxist ideology, and its political motivations were realised after the 1917 Bolshevik Revolution through manifestos, sculpture, painting and architecture. Two originators of the group were Russian sculptors: Naum Pevsner (1890–1977), who worked under the name Naum Gabo, and his older brother, Antoine Pevsner (1884–1962). Concurrent with Kasimir Malevich's founding of the Suprematist art movement in 1915, Russian artists were turning towards abstraction and rejecting representation. In 1916 a 'war' of differences between Suprematist and Constructivist ideology broke out, visible in the art of Alexander Rodchenko (1891–1956), with his *Black on Black* compositions (*c.*1918) counteracting Malevich's *White on White* series.

The political impulse is clear in paintings by the Russian artist, engineer, architect and typographer Lazar Markovich Lisitsky (1890–1941), better known as El Lissitzky – such as in *Beat the Whites with the Red Wedge* (*c.*1919), printed as a street poster illustrating both factions in the Russian Civil War. El Lissitzky created the concept of *Proun*, an abbreviation of the Russian 'project for the

affirmation of the new', for a series of geometric paintings aimed at social change. To Constructivists, painting and sculpture were merely part of a process to highlight society's needs; their focus was on the pure form of industrial architecture and utilitarian objects.

Vladimir Tatlin (1885–1953), a Russian artist, designer and a co-founder of the Constructivist movement, studied at the Moscow School of Painting. He practised constructional sculpture from 1913 on, making abstract works in wood, metal and glass. His constructions dating from 1915–16 were free-form suspensions. Tatlin is remarkable for his unbuilt project – *Monument to the 3rd International* (1919–20) – a vast construction to be engineered from iron and steel, wood and glass, and intended when built to be taller than the Eiffel Tower, its spirals adding a dynamism to the metal frame.

A result of Constructivism was the creation in 1918 of a state-run school of design, later known as *Vkhutemas* (the abbreviation for Higher Art and Technical Workshops), which trained artist-designers – the artist Liubov Popova, for example, taught textile design there. It was similar to the workshops of the Bauhaus (1919–33).

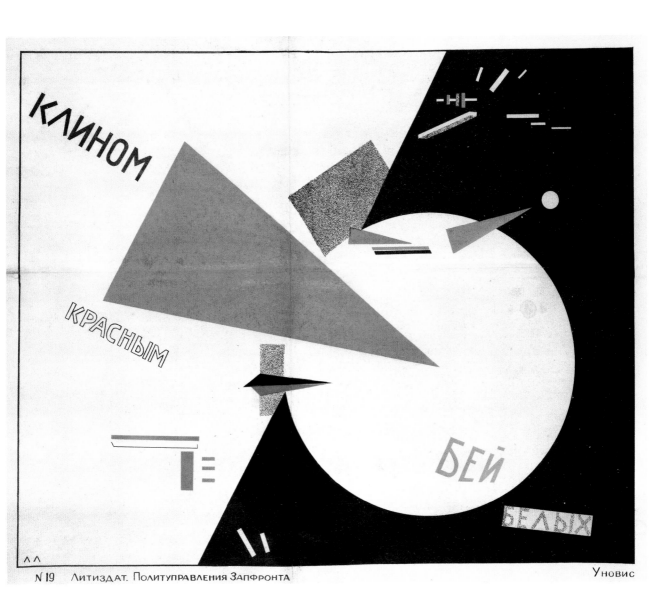

El Lissitsky, **Beat the Whites with the Red Wedge**, *c.*1919, colour lithograph, 46 x 55.7 cm
Private collection

c.1900–1960

Literature published towards the end of the 19th century, combined with artists' interest in the subconscious inner self, as visualised in Symbolism, raised awareness of the 'other'. In 1887 Friedrich Nietzsche's (1844–1900) *On the Genealogy of Morals* and in 1899 *The Interpretation of Dreams* by Sigmund Freud (1856–1939) added to the interest shown by artists in primitive, emotional response, particularly in sexual behaviour. Paul Gauguin had first traversed this path with his interpretation of the 'primitivism' of Polynesian tribes in Tahiti, observing, from a Western perspective, the life of the 'noble savage' in gendered observations. He stated (in a letter to August Strindberg, 1895) that he visualised women as the fertile 'other', close to nature with their primeval instincts.

The literature led painters to study the art of Africa and Oceania through artefacts in ethnographic museums. African masks were prized as possessions, as were informed compositions such as *Blue Nude* (1907) by Henri Matisse or Pablo Picasso's *Head* (1907), *Mother and Child* (1907) and *Les Demoiselles d'Avignon* (1907), a scene from a brothel revealing his interest in the 'primitive' through his depiction of prostitutes.

The primitive 'otherness' was visualised through Western eyes and evident in the return to nature paintings by the naïve painter Henri Rousseau (1844–1910). The former customs official did not travel so he populated his world of jungles with the wild animals and plants he sketched in the zoo and botanical gardens of Paris. Rousseau conveyed a lush, rich 'otherworldliness' in paintings such as *The Snake-Charmer* (1907) and his last work, *The Dream* (1910).

The French writer André Gide (1869–1951) linked naturism to freedom (*Les Nourritures terrestres*, 1897), releasing the inner barbarian in a spontaneity that also excited the advocates of Fauvism. The influence of French interest in primitive art is visible in *Kneeling Mother and Child* (1907) by the German artist Paula Modersohn-Becker (1876–1907), who worked in the arts commune of Worpswede, near Bremen. Her exposure to works by Cézanne and Gauguin during time spent in Paris affected her like a shock wave. German artist Emil Nolde's produced his disquieting series of paintings *Masks* (1911) after visiting the Museum of Ethnology in Berlin.

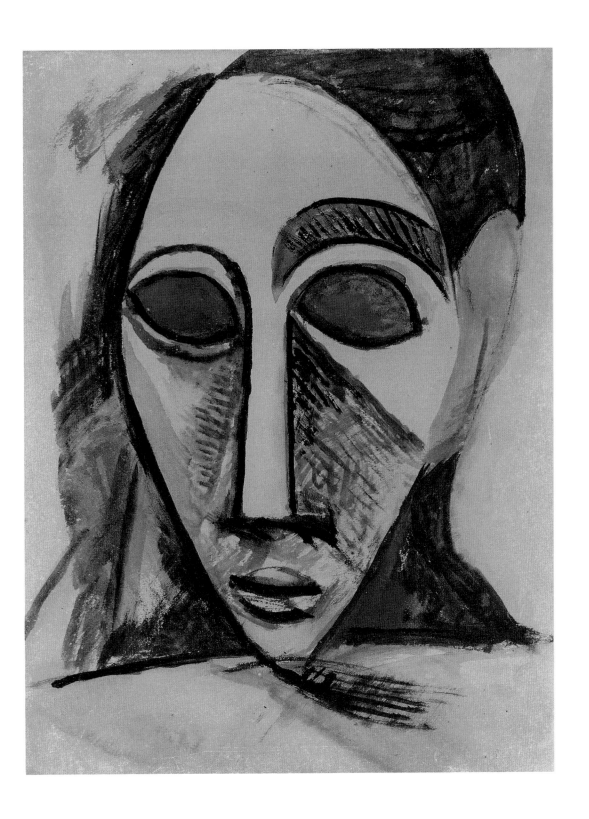

Pablo Picasso, **Head**, 1907, watercolour and gouache on paper, 30.8 x 23.8 cm
Private collection

AMERICAN SCENE PAINTING / ASHCAN SCHOOL

1912–1940s

It was at the same exhibition that first displayed the modern European art of Edgar Degas, Paul Cézanne and Marcel Duchamp (*Nude Descending a Staircase, No. 2*, 1912) in the USA – the Armory Show (officially: International Exhibition of Modern Art) of 1913 – that the young American artist Edward Hopper (1882–1967) first sold one of his works: *Sailing* (1911). Although unwilling to be labelled part of a group, Hopper was a practitioner of American Scene Painting. So, too, George Bellows (1882–1925), who exhibited five paintings and a number of drawings at the Armory Show. Hopper and Bellows had met as students at the New York Art School (known as The Chase), both taught by 'Realist' painter Robert Henri (1865–1929), leader of the 'Ashcan School' in New York.

In the 1890s, after studying for two years at the Pennsylvania Academy of the Fine Arts, and in Paris at the Académie Julian, Henri initiated urban realist art in the 'Philadelphia Realists' group with William Glackens (1870–1938), George Luks (1866–1933), Everett Shinn (1876–1953) and John Sloan (1871–1951). Between 1896 and 1904 they moved to New York. With the addition of George Bellows it was the beginning of what

became known as the Ashcan School, their art reflecting life in the modern city. Henri's dictum was 'art for life's sake' (as opposed to 'art for art's sake'), intended to make artists paint what they saw around them. Examples of this are John Sloan's *The Hairdresser's Window* (1907) and *McSorley's Bar* (1912), which capture diverse elements of daily city life and make the viewer part of it.

The term 'Ashcan' defines the group's aesthetic and was suggested by one of George Bellows's drawings – *Disappointments of the Ash Can*, illustrating out-of-work men looking through a dustbin for food – which appeared in the *Philadelphia Record* in April 1915. An art critic acerbically used 'Ash Can' to describe the realism of urban culture depicted in the group's steamy street-life scenes. Bellow's 1909 series of six prizefight boxing scenes captures the intensity of American Realism in painting, giving the viewer a ringside seat of sweat, blood and passion. *Stag at Sharkey's* (1909) – 'stag' meaning 'prizefight' – conveys the atmosphere of a boxing match in a private club with his depiction of a mixed public. Bellows's close-cut format puts the spectator at the ringside, providing a view of life at street level.

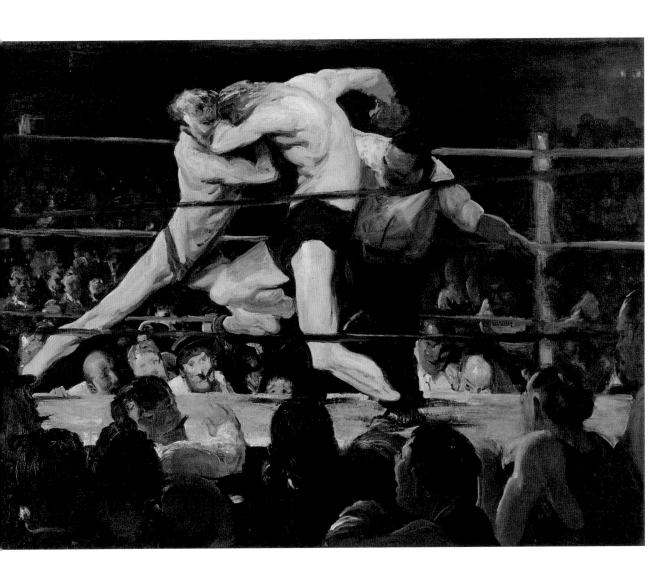

George Bellows, **Stag at Sharkey's**, 1909, oil on canvas, 92 x 122.6 cm
Cleveland Museum of Art, Ohio, USA

c.1920–1940

In its original form it was referred to as *L'Art Decoratif* and was associated with the *Exposition Internationale des Arts Décoratifs et Industriels Modernes,* an international fair held in Paris in 1925. The retrospective term 'Art Deco' was created in the 1960s during a short revival of its style to differentiate it from the original movement. Nowadays, Art Deco commonly refers back to the 'golden age' of art and design, synonymous with a flamboyant style at its height in Europe and America in the 1920s and 1930s. Primarily associated with the decorative arts, it symbolised elegance, wealth and luxury, opulent ornamentation and modernity available not just for the rich but the middle classes, too.

The Art Decoratif movement began between 1908 and 1912 at a time when interest in Art Nouveau was waning. Many threads pulled the style of Art Deco together. In Paris the modernity and theatricality of Russian entrepreneur Sergei Diaghilev's Ballets Russes entertained Parisians in 1909, with exotic costumes designed by Russian artists. Its influence spread to fashion, supported by French magazine illustrations of costumes, jewellery, hairstyle, interior design and, importantly, lifestyle. Pre-1914 Art Deco

in French graphic art is exemplified in the fashion illustrations of Romain de Tirtoff (1892–1990), known as Erté, and illustrator Georges Barbier (1882–1932). The movement regained momentum after World War I in Europe and America, peaking during the interwar period from around 1925 to 1935.

In her painting *Self-Portrait in the Green Bugatti* (1929), Polish artist Tamara de Lempicka (1898–1980) illustrates the glamour, exoticism, mystery and feminine allure of Art Deco trademarks: modernity in the luxury open-top sports car driven at speed, the latest fashion in cropped, bobbed hairstyle kept in place with an aviator-style geometric head-cover. Her face portrays hooded, sensual eyes, an emancipated woman going places, in control.

After the 1925 Paris Exposition – which featured artist-architect Le Corbusier's concept of a 'machine for living in' and his Pavillon de L'Esprit Nouveau, conspicuous for its white walls and bare simplicity – the style of Art Deco was streamlined and made more geometric, in line with other movements in art. In its designs for jewellery to fashion and architecture, the emphasis was on modernity and modern life, not exoticism.

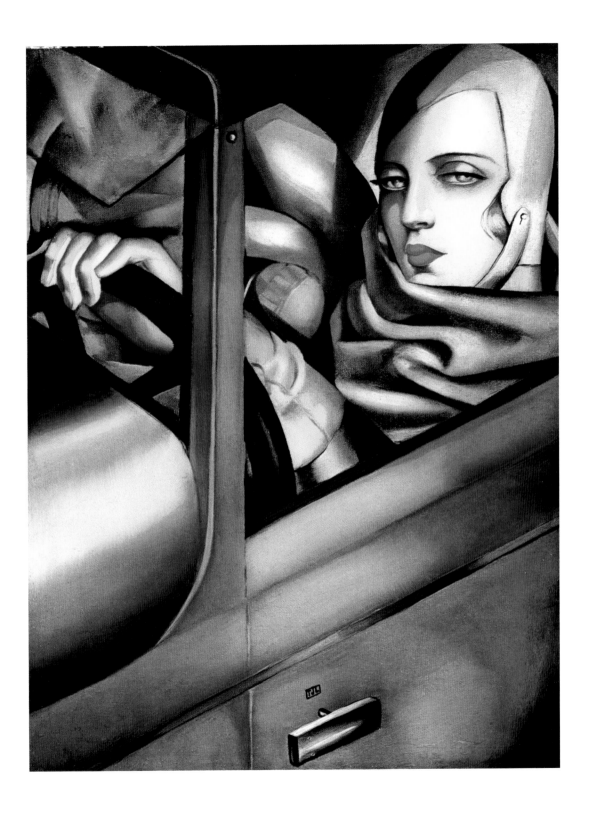

Tamara de Lempicka, **Self-Portrait in the Green Bugatti**, 1929, oil on wood, 35 x 26 cm
Renaud Collection, Basel, Switzerland

FIRST SCHOOL OF PARIS

c.1900–1939

The umbrella term École de Paris (School of Paris) refers to the group of foreign artists who gravitated to Paris from 1900 until the beginning of World War II to study French art, to enrol at the academies, to sell their art and to be part of the Parisian art world, which up until the outbreak of war was still the centre of the modern art world.

Some, like Spanish artist Pablo Picasso, moved to France in 1904 and stayed permanently, while others stayed for only a short period, like the Italian Giorgio de Chirico, who spent the years 1911 to 1915 in France, then went back home, only to to return to France in 1920. All were infused with the vibrancy of the art market, the galleries and art schools. The term embraces the exchange of ideas between French artists such as Henri Matisse and Pierre Bonnard and their association with with non-French artists of different nationalities.

The 'school' included many famous names: from Romania, Constantin Brancusi (1876–1957), who set off for Paris on foot in 1903 and was enrolled at the École des Beaux-Arts from 1905 to 1907. Brancusi is recognised as a pioneer of Modernism, simplifying form in his sculptural practice. From Russia, Marc Chagall (1887–1985) arrived in 1910, and associated with Robert Delaunay and Guillaume Apollinaire; returning home in 1914, he was prevented from going back to Paris by the outbreak of war and did not return there until 1923. Italian artist Amedeo Modigliani (1884–1920) is indelibly associated with the School of Paris. After studying at the Académie Colarossi in 1906, he exhibited at the Salon d'Automne in 1908 and 1912 and at the Salon des Indépendants in 1907, 1910 and 1911. Living in Montparnasse he befriended many artists. In 1909 he and Brancusi worked together, which inspired Modigliani to create his first sculptures. Belorussian artist Chaim Soutine (1893–1943) arrived in 1913; Russian artists Natalia Goncharova (1881–1962) and Mikhail Larionov (1881–1964) came to Paris with impresario Sergei Diaghilev as designers for the Ballets Russes, returning in 1917 to live and work permanently in Paris.

Following the rise to power of the Nazi Party in Germany in 1933, many Jewish architects, writers and artists branded as degenerate because of their practice of avant-garde art emigrated to Belgium, Switzerland, Holland, France, Britain, and America.

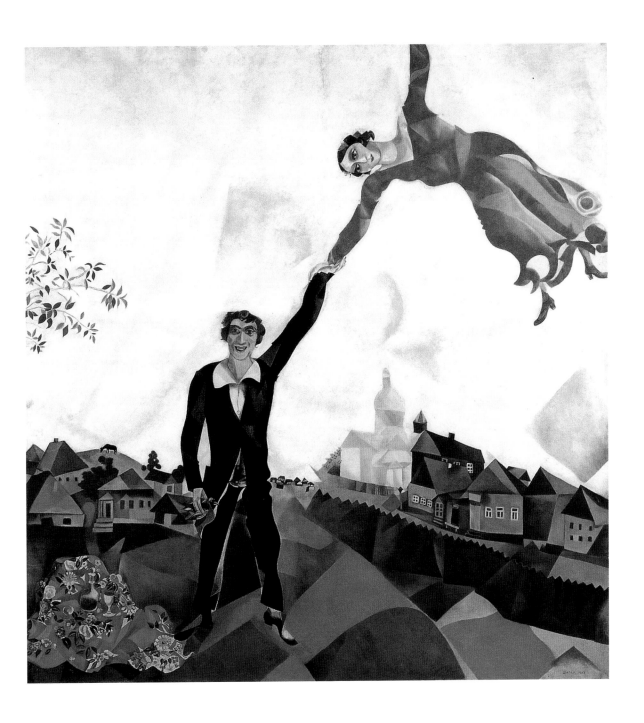

Marc Chagall, **The Promenade**, 1917–18, oil on canvas, 169 x 163 cm
The Russian Museum, St Petersburg, Russia

RUSSIAN AVANT-GARDE

<div style="text-align: right">

1905– early 1930s

</div>

Breaking away from the constraints of the Russian Imperial Academy in 1863, groups of artists sought to paint the realism of life in Russia and to turn to the art heritage of their country. The *Peredvizhniki* (Wanderers) art group, for example, included Ilya Repin (1844–1930), Nikolai Yaroshenko (1846–1898) and Vladimir Makovsky (1846–1920), pioneers of pre-20th-century Russian avant-garde who took art to the people in touring exhibitions. Artists were aware of modern European art and were free to travel to study and work in other countries. Russia had its own 'Courbet' in Repin, revered for his realist paintings of Russian life, identified in his seminal work *Barge-Haulers on the Volga* (1870–73).

The *Ambramtsevo* circle, an arts colony supported by the industrialist and patron of the arts Savva Mamontov, included Repin and, notably, Mikhail Vrubel (1856–1910), who came to prominence for his art restoration of the 12th-century St Cyril Church in Kiev, and his *Demon* series of paintings – such as *Demon Seated* (1890) and *Demon Downcast* (1902) – which show Vrubel's interest in Symbolism and his use of a multifaceted technique that anticipated Cubism. Vrubel's paintings were exhibited by

Russian impresario Sergei Diaghilev (1872–1929) in Paris in 1906. Diaghilev, co-founder with artists Alexandre Benois (1870–1960) and Léon Bakst (1866–1924) of the influential *Mir Iskusstva* (World of Art) magazine (1899–1904), promoted opera, ballet and Russian art. His Paris-based dance company, Ballets Russes, caused a sensation when it first performed there in 1909, and turned the spotlight on Russian stage and costume designers, particularly Léon Bakst (1866–1924).

The art of the painter, textile designer and committed Constructivist Liubov Popova (1889–1924) – *Seated Figure* (c.1914) – serves to highlight the different motivations of Russian avant-garde artists, in contrast to Natalia Goncharova (1881–1962) and Mikhail Larionov (1881–1964), who were instrumental in the promotion of Russian painting through the *Bubnovy valet* (Knave of Diamonds) group with an interest in Primitivism and Russian folk art. The first exhibition in 1910 featured French painters alongside Russian artists. In 1911 Goncharova and Larionov co-founded the *Oslinyi Khvost* (Donkey's Tail) arts group with fellow Russians Marc Chagall (1887–1985), Kasimir Malevich (1878–1935) and Alexander Shevchenko (1883–1948).

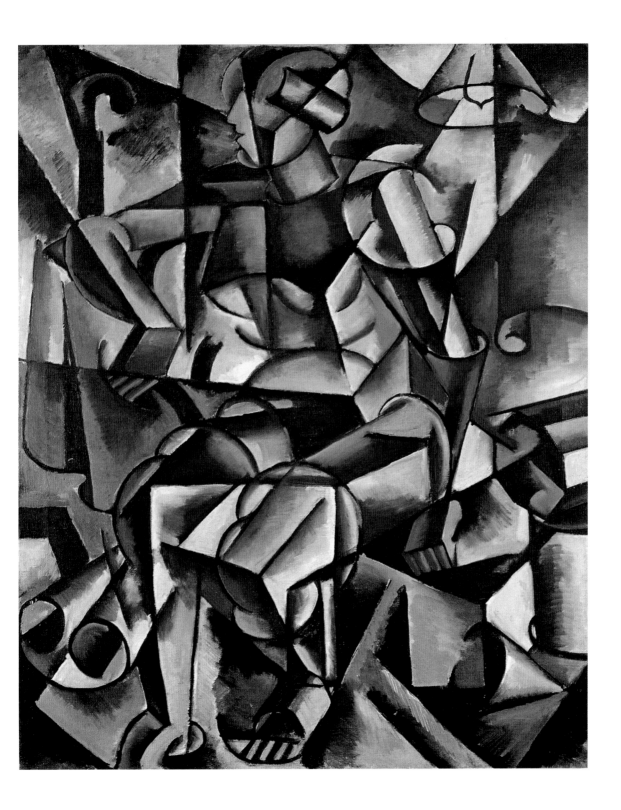

Liubov Popova, **Seated Figure**, *c.*1914, oil on canvas, 106 x 87 cm
Private collection

METAPHYSICAL ART

<div align="right">

1910–
mid-1930s

</div>

Metaphysical art (1911–19) is primarily associated with the Italian artists Giorgio de Chirico (1888–1978) and Carlo Carrà (1881–1966). De Chirico, a poet, theatrical designer, painter and sculptor who was born in Greece to Italian parents, officially launched the *Scuola Metafisica* – metaphysical school – with Carrà and his own younger brother, the writer Alberto Savinio (1891–1952), in 1917. But de Chirico's metaphysical art dates from 1910–11, inspired by the philosophical writings of Friedrich Nietzsche (1844–1900), in particular the theory of an eternal recurrence, the circularity of time where the past recurs. In painting, metaphysical art represented an alternative to Futurism.

It was the French poet and art critic Guillaume Apollinaire (1880–1918) who, in 1913, applied the term 'metaphysical' to de Chirico's work of 1910–11. Apollinaire described it as having an element of surprise. The artist composed his paintings of deserted Italian piazzas, isolated buildings, classical statues or mannequins, confined spaces or vast, open spaces and receding arcades like theatrical set-pieces, with distorted perspectives aimed at creating a disconcerting view of the unknown. *Melancolia*

(1912), *The Silent Statue* (*Ariadne*) (1913), *The Uncertainty of the Poet* (1913), *The Song of Love* (1914) and *Piazza d'Italia* (1915) are defining examples. De Chirico was lauded by the Surrealists who identified with his work.

Carlo Carrà, born in Piedmont, northern Italy, first associated with the Futurists, contributing in 1910, along with Umberto Boccioni and Luigi Russolo, to the *Manifesto of the Futurist Painters* and *Technical Manifesto of the Futurist Painters*. In 1913 he published his own manifesto, *The Painting of Sounds, Noises and Smells*. Carrà copied de Chirico's use of a mannequin for figures. In *The Metaphysical Muse* (1917) he included a map of Istria and a target, painted during World War I while performing his military service at a hospital for nervous diseases in Ferrara. Although Carrà painted few works in subsequent years, he did publish a book, *Pittura Metafisica*, in 1919 and contribute to the art magazine *Valori plastici* (1918–22) to promote metaphysical art. Those involved in the periodical organised two travelling exhibitions to Germany in 1921 and 1924, which influenced the work of George Grosz, Oskar Schlemmer and Max Ernst, among others.

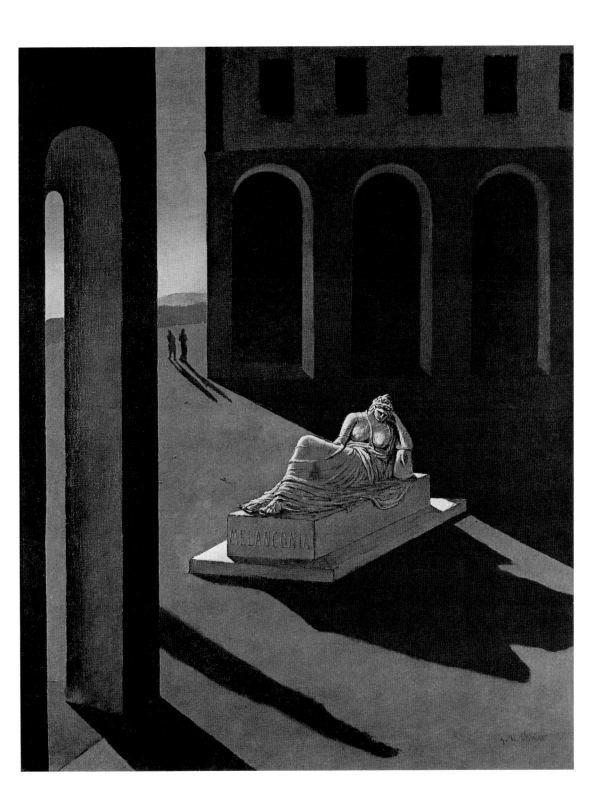

Giorgio de Chirico, **Melanconia**, 1912, oil on canvas, 78.5 x 63.5 cm
Private collection

GEOMETRIC ABSTRACTION / ABSTRACT ART

c.1915–1925

Early indications of abstract art developed in the work of Russian artist Wassily Kandinsky (1866–1944) from his interest in Expressionism, with Kandinsky improvising his landscape paintings to produce dynamic, highly colourful, painterly art. Dutch artist Piet Mondrian (1872–1944) on the other hand took his abstract forms from analytical Cubism, preferring geometric compositions – straight lines, rectangles, squares – and linear shapes created using primary colours. Mondrian stayed in Paris from 1911 until 1914, experimenting with Impressionism, Fauvism and Cubism. *Composition (Tree)* (1913; Tate Gallery, London) and the *Pier and Ocean* series from 1914–15 are early indicators of his future methodology. Taking the monotones of Cubist art to form his first abstract compositions, Mondrian stated: 'To create pure reality plastically, it is necessary to reduce natural forms to the constant elements of form, and natural colour to primary colour.' Having gone back to Holland in 1914, Mondrian found himself unable to return to France because of the outbreak of World War I. Away from the centre of the art world he concentrated on refining his abstraction theory, using only vertical and horizontal

elements and initially eliminating colour from his work.

The analytical Dutch art group De Stijl, of which Mondrian was a chief member alongside Theo van Doesburg (1883–1931), Bart van der Leck (1876–1958) and architect Jacobus Johannes Pieter Oud (1890–1963), published a magazine of the same name in 1917, the year that the modular grids synonymous with Mondrian's work first appeared, developed in five *Compositions with Coloured Planes* (1917). In 1919 Mondrian published a series of writings collectively titled *Neo-Plasticism*. The term came to define his art of black grids filled with primary colours over a white, grey or black background, as illustrated in *Composition* (1919; Galleria d'Arte Moderne, Rome, Italy). Further requisites included right-angle lines only in a horizontal-vertical position. Mondrian wanted art to be built from abstract elements for purity of expression. His own interest in theosophy, anthroposophy and Neo-Platonism guided his relationship to art practice.

Theo van Doesburg, a practitioner of geometric abstract art, published *The Principles of Neo-Plasticism* in 1925, compounding the movement's theories.

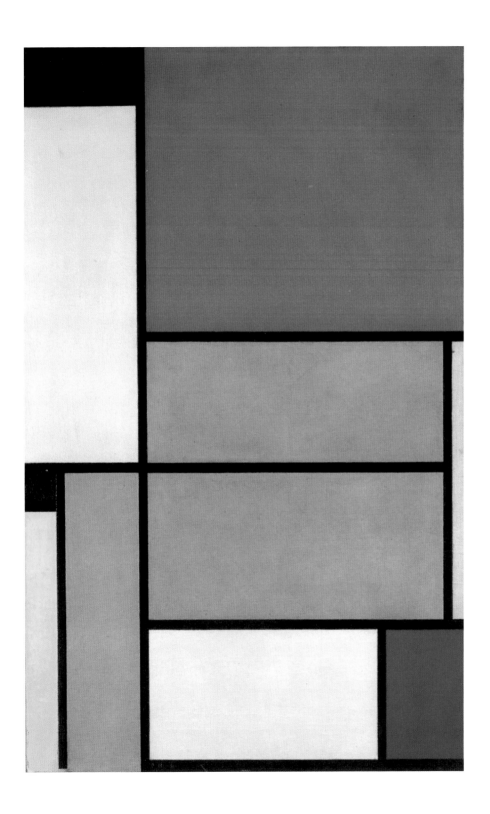

Piet Mondrian, **Tableau I**, 1921, oil on canvas, 96.5 x 60.5 cm
Museum Ludwig, Cologne, Germany

VORTICISM

c.1913–1919

Vorticism is notable as the British contribution to modern art immediately before and during World War I. The art movement was founded in England in 1914 by a well-travelled English artist and writer, Percy Wyndham Lewis (1882–1957), who was familiar with the art of the Post-Impressionists, Futurists and German Expressionists, geometric abstraction and Cubism. It was both a British alternative and challenge to Futurism and Cubism, and a fusion of the two. Lewis's Vorticists emerged from the London art school created by him in 1913 and known as the Rebel Art Centre. The Vorticist name was taken from an essay, 'Vortex', written by the American poet Ezra Pound (1885–1972), a London friend of Lewis's. He wrote: 'The vortex is the point of maximum energy. It represents, in mechanics, the greatest efficiency. We use the words "greatest efficiency" in the precise sense – as they would be used in a text book of mechanics.'

In London a meeting with the Italian founder of Futurism, Filippo Tommaso Marinetti, triggered Lewis's interest in creating an English alternative to Futurism. He wanted British artists, not Italian, to rule modern art. His polemic was unleashed in *BLAST*, the radical Vorticist journal, which ran for two editions (1914–15), and launched the Vorticist Manifesto, written by Lewis and signed by Ezra Pound, Richard Aldington, Malcolm Arbuthnot, Lawrence Atkinson, French sculptor Henri Gaudier-Brzeska, Jessica Dismorr, Cuthbert Hamilton, William Roberts, Helen Sanders and Edward Wadsworth. Among others associated with the group were Jacob Epstein, David Bomberg, Christopher Nevinson, Dorothy Shakespear and Frederick Etchells. The Vorticists held one exhibition, at the Doré Gallery, London, in 1915.

In Lewis's early watercolour *The Vorticist* (1912), a move towards figurative abstraction, the robot-like figure establishes the power of the machine. In sculpture Jacob Epstein's extraordinary mechanised abstract figure *Rock Drill* (1913) captures the 'mechanical' essence of Vorticism, a progressive push towards abstraction. During World War I, many artists, including Lewis, enlisted and served at the front, affecting their view on life and their art. Lewis worked for a period as a war artist. Vorticism did not survive post-war, but the originality of *BLAST*'s typography did transform British graphic design.

Percy Wyndham Lewis, **The Vorticist**, 1912, watercolour, ink and chalk on paper, 41.4 x 29.4 cm
Southampton City Art Gallery, Hampshire, England

NEW OBJECTIVITY

1918–1933

In 1925 Gustav Friedrich Hartlaub (1884–1963), director of the gallery Städtische Kunsthalle in Mannheim, Germany, used the term 'Neue Sachlichkeit' (New Objectivity) for an exhibition of 124 works by 32 artists, to describe the work of German artists that reflected a different form of Expressionism, one that challenged its idealism and romanticism. His original title had been 'Post-Expressionism'. Hartlaub explained his reasoning behind 'new objectivity'. The negative view related to the general feeling of resignation prevailing in Germany after a period of exuberant hope; the positive side was to take things entirely objectively. Artists had used brutal satire to expose corruption in Germany in the aftermath of World War I. It was emotionally detached, caricatured with grotesque, distorted figures portraying social imbalance and deprivation rather than a ferocious reaction to events. Their honest 'objectivity' reflected what they observed in the lives of people.

Among the Neue Sachlichkeit group in 1925 were George Grosz (1893–1959), Otto Dix (1891–1969) and Max Beckmann (1884–1950). Grosz in particularl hated the German military on account of his experiences during the war, which included seeing action from 1914 on, suffering shell-shock, spending time in a military hospital and mental institution, and facing the threat of execution. He caricatured what he experienced and saw in *Suicide* (1916) and *Fit for Active Service* (1916–17). Grosz stated: 'War to me was never anything but horror, mutilation and senseless destruction.' He highlighted the lives of crippled and disabled ex-soldiers forgotten at war's end. After the war, he targeted authority, military officials and racketeers, as in *The Pillars of Society* (1926).

Otto Dix volunteered for the German army in 1914, fighting throughout the war and earning the distinction of the military Iron Cross. After the war, his support for the German government dissipated and Dix utilised his art to expose the corruption evident in Germany, using cynical humour to emphasise the fate of ex-servicemen in *Skat Players* (1920; later titled *Card-Playing War Cripples*). Max Beckmann volunteered for the military medical corps in 1914 and served near the front lines in Ostend and Lille. He was released from military duties in 1915 after suffering a nervous breakdown. His seminal work *Night* (1918–19) serves to demonstrate his experiences.

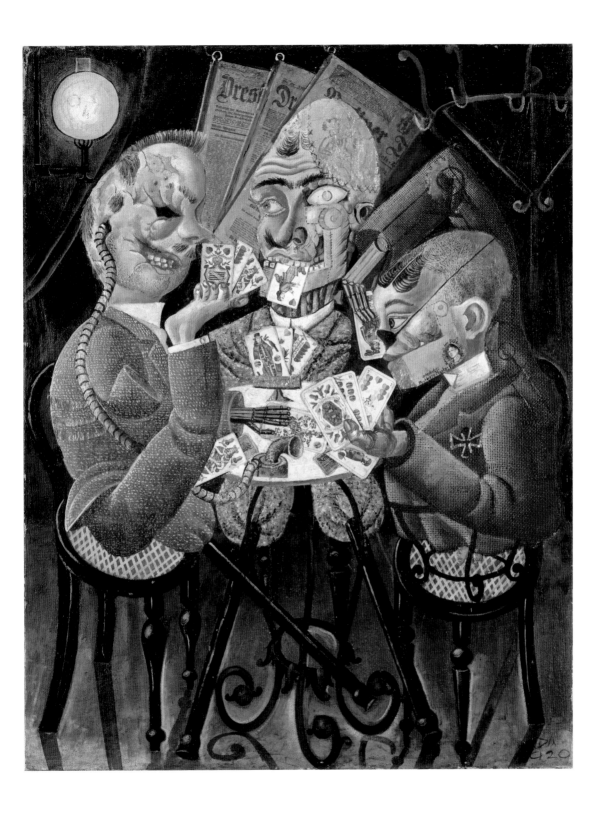

Otto Dix, **The Skat Players**, 1920, oil on canvas, 110 x 87 cm
Staatliche Museen zu Berlin, Neue Nationalgalerie, Germany

CONCRETE ART

<div align="right">

c.1930–1960

</div>

The concept of 'art concret' was already being used in 1924 by the Dutch artist and designer Theo van Doesburg (1883–1931) to describe a different type of non-figurative art. It was officially launched in *Base de la peinture concrète* (The basis of concrete art), a manifesto signed by van Doesburg, French artist Jean Hélion (1904–1987), Armenian artist Léon Tutundjian (1905–1968) and Swedish artist Otto G. Carlsund (1897–1948), who organised its publication. The manifesto clarified that 'The painting should be constructed entirely from purely plastic elements, that is to say, planes and colours. A pictorial element has no other significance than "itself" and consequently the painting possesses no other significance than "itself".' The Manifesto was printed in the first and only issue of *Art Concret* (April 1930). The movement was close in its theories to Suprematism, Constructivism and Neo-Plasticism.

Van Doesburg's *Counter-Composition* (1925–26) explores the artist's principle according to which 'the technique must be mechanical', without expression. In the later, superb *Arithmetical Composition 1* (1930), which shows the work of the artist in its most spiritual and mechanical form, the mathematical element of its design allows for its infinite continuation as an endless construct. The movement's concept of concrete art was a cerebral abstract art that carried no symbolism and was completely free of any kind of figurative realism. It focused on line, colour and plane in simplified geometric forms. Van Doesburg stated that 'Nothing is more concrete, more real than a line, a colour, a surface ...' He admired the geometric spiritual character of Piet Mondrian's art – which Mondrian himself described as Neo-Plasticism – for its use of only primary colours: red, blue and yellow in a black grid.

Van Doesburg's premature death in 1931, the year after the manifesto was published, left other artists to promote its aesthetic. Notable among them was the Swiss artist, architect and designer Max Bill (1908–1994), who organised the first 'concrete art' exhibition, *Konkrete Kunst*, in Basel in April 1944. His literary contributions include those made to the art journal *Abstrakt Konkret* (1945), and an essay, 'The Mathematical Way of Thinking in the Visual Art of Our Time' (1949). The defining character of Concrete Art was established between 1945 and 1960, and influenced the creation of Op Art in the 1960s.

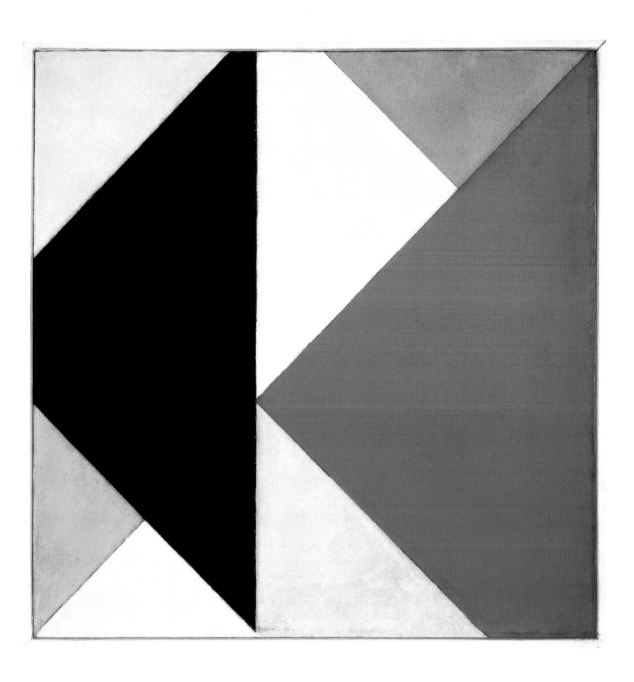

Theo van Doesburg, **Counter-Composition**, 1925–26, oil on canvas, 49.5 x 50 cm
Peggy Guggenheim Foundation, Venice, Italy

SOCIALIST REALISM

Socialist Realism established itself in Russian art from the early 1930s on. The term is synonymous with communist political propaganda in Russia and other communist countries. Its message was promoted on posters and in murals and public art in a move by the authorities to use art as a medium to spread socialism. It was cultivated in Russia after the 1917 Bolshevik Revolution, when the new state pondered on a content-over-form art for its people. In the 1920s the Marxist Leon Trotski (1879–1940), founder of the Red Army, spoke of a desire for a return to traditional painting with disdain for Futurism and avant-garde art. It signified a change in Russian painting towards informing and promoting a socialist movement whereby the work of the people was shown to be heroic, essential and greatly respected. Arts groups such as the *AKhRR* (Association of Artists of Revolutionary Russia), set up in 1921–22, moved towards documentary 'heroic realism'. *Death of a Commissar* (1928) by Kuzma Petrov-Vodkin (1878–1939) reflects duty, comradeship and sacrifice for one's country. It was exhibited in 1928 by *AKhRR* to honour the 10th anniversary of the Red Army. Another group, the *OSt* (Society of Easel Painters), painted

contemporary documentary realism, for example *The Defence of Petrograd* (1928) by Alexandr Deyneka (1899–1969).

From 1932 on Socialist Realism was was an established art form: socialist in content, realistic in composition. Yuri Pimenov's (1903–1977) *New Moscow* (1937) is composed like a photo taken from the rear passenger seat of an open-top car driven by a young woman. There are lots of cars on the street, new, high-rise buildings in the distance, a sign for the new metro and many people going about their business. The snapshot conveys the city's modernity embraced by its active community. Deyneka's painting *Future Airmen* (1938), considered one of the best examples of Socialist Realism, depicts the flight of an aeroplane and three boys watching its progress and symbolises future generations defending the nation. In the 1940s, patriotism was promoted during the German-Soviet war, and the heroism of patriots dominated Socialist Realist art in the aftermath of the war. *A Letter from the Front* (1947) by Aleksandr Laktionov (1910–1972) won the 1948 Stalin Prize. Today it is included in exhibitions on Soviet Socialist Realism because it exemplifies the movement's vision and ideology.

Mikhail Ivanovich Khmelko, **Unification of the Ukrainian Lands in 1939**, 1949, tempera on paper, 45.7 x 48.2 cm
Springville Museum of Art, Utah, USA

FANTASTIC REALISM

<div style="text-align: right">

From 1946 onwards

</div>

The Vienna School of Fantastic Realism – a term coined by Austrian art critic Johann Muschik – was formed after World War II. It produced art that was a fusion of Symbolism, Surrealism and Northern Renaissance. Its fantasy, hyper-real content was created with the careful precision of the Old Masters. In 1946 Albert Paris Gütersloh (1887–1973), a prolific writer, artist, actor and stage designer, took a post as arts tutor at the Vienna Academy of Fine Arts. He had had studied painting with Gustav Klimt and worked with Max Reinhardt. It was Gütersloh's focus on the techniques of Flemish artist Pieter Bruegel, the Elder (1525–1569), Hieronymus Bosch (1450–1516) of the Netherlands and German-born Albrecht Dürer (1471–1528) that defined his style. Gütersloh's teaching and the subsequent artworks of his students inspired the term 'Fantastic Realism'.

Gütersloh's group, interested in the philosophies and theories of Nietzsche, Schopenhauer, Freud and Jung, looked to a variety of visual sources from ancient myth to religion, to the reality of life in post-war Austria. Artists Ernst Fuchs (b. 1930), Arik Brauer (b. 1929), Rudolf Hausner (1914–1995), Wolfgang

Hutter (b. 1928), Anton Lehmden (b. 1929 in Slovakia), and Fritz Janschka (b. 1919) formed the first wave of Fantastic Realists. Helmut Leherb (1933–1997) was one of the younger, second wave. Curt Stenvert (1920–1992), who was originally associated with the group, moved to film-making in 1951.

The Fantastic Realists met up at different studios in Vienna, notably Hausner's and that of Surrealist painter Edgar Jené (1904–1984). Fuchs is noted for his phenomenal drawings, particularly *Woman's Reflection in a Window* (1946), the triptych *Satan's Heaven* (1954) and *Christ before Pilate* (1957).

Fritz Janschka's *Where Are You Going?* (1947), painted as a symbol of Vienna during wartime bombardment by the US Air Force, is a masterpiece by the group. A major exhibition of Fantastic Realism was held at Belvedere Castle, Vienna, in 1959–60. The artists continued to produce a series of masterly art, as in Hausner's *The Ark of Odysseus* (1953–56), and Brauer's *The Wind-Maker* (1966–67), which confirmed that artists of the Viennese School of Fantastic Realism were as important as their predecessors, the Vienna Secessionists.

Rudolf Hausner, **The Ark of Odysseus**, 1953–56, tempera and resin on plywood, 85 x 141 cm
Wien Museum, Vienna, Austria

1940s–1950s

Art Informel (unformed or formless art) describes a new type of art that emerged in Paris in the 1940s. The name was created from the word *informel*, used by French writer and critic Jean Paulhan (1884–1968) to describe the work of French artist Jean Dubuffet (1901–85). *Art autre* (art of another kind) was coined by French writer and critic Michel Tapié (1909–87) when discussing the work of German artist Wols (1913–1951). Both artists produced gestural, expressive art viewed as a rejection of the ordered compositions of geometric abstraction. Paintings by *Informel* artists took on the visual naivety of children's art, but one that was painted in a raw, brutal, disembodied manner – possibly a comment on the human condition at the cessation of war. It may be seen as a catharsis, a form of visual purging and cleansing. *Informel* is now used as an umbrella term for its fragmented divisions of Abstract Expressionism and Action Painting, Tachisme, Gesture Painting and Lyrical Abstraction.

In 1951 Tapié organised an exhibition, *Signifiants de l'Informel,* at Studio Facchetti, in Paris, exhibiting works by, amongst others, Dubuffet, Jean Fautrier (1898–1964) and Georges Mathieu

(1921–2012). (Fautrier would later damn the exhibition as 'an empty spectacle for export'.) The following year Tapié curated another exhibition, *Un Art Autre*, and published a book of the same name. Both the exhibition and the book recognised an art movement turning away from geometric abstraction and Surrealism, which had dominated the École de Paris before 1939. Artists included Dubuffet, Wols, Alberto Burri, Fautrier, Ruth Francken, Karel Appel and Willem de Kooning (1904–1997). Dubuffet had pioneered this change. His *haute pâte* (pulp) paintings, such as *Volonté de Puissance* (1946), brought attention to his work. They were created from thick paste with additional materials, including asphalt, tar, white lead and coal, pebbles, sand and straw. The thick surface of the paint was scratched to resemble graffiti. Many of Dubuffet's works, such as *Léautaud, Redskin-Sorcerer* (1946), borders on *Art Brut* (raw art), a name he gave to the art of the mentally ill, which he collected. The roughly outlined human image is both bleak and distressing.

Jean Dubuffet, **Léautaud, Redskin-Sorcerer**, 1946, oil on canvas with pebbles and gravel, 92.1 x 73 cm
Museum of Modern Art, New York City, NY, USA

1940s–1950s

Tachism, from *tâche*, the French word for 'blot' or 'stain', was appropriated by French art critic Charles Estienne to describe a gestural application of blotches or stains of colour. The artwork was created rapidly with deep, graffiti-type scratches, the artist's mark often evident and often near-abstract. Tachism is defined as a European form of American Action Painting under the umbrella of *Art Informel*.

The French artist and sculptor Jean Fautrier (1898–1964) is the foremost name associated with this movement. His disturbing series of paintings and sculptures *Hostages* (1943–45) are closely related to his war experiences. The paintings are thickly encrusted with handmade plaster or a thick impasto daubed onto paper with a knife and mounted onto canvas. The vague outline of a head, figure or near-abstract shape was scratched into or marked on the surface. There were 33 paintings and sculptures in the series, beginning with *Head of a Hostage, No.1* (1943), in oil and and other materials on mounted paper. Fautrier was arrested briefly in 1943 for his part in a resistance circle of writers and artists in Paris. He moved to Châtenay-Malabry on the outskirts of

Paris. He stated that from his studio he could hear the screams of French prisoners brought to a nearby forest by the German army for torture and execution. This helpless situation informed his work. *Head of a Hostage* (1944; Tate Gallery, London), cast in lead, is the last sculpture in the series.

Georges Mathieu (1921–2012) took quite a different approach in his exploration of Tachism. The bright splashes of colour 'calligraphy' visible in his exuberant, explosive painting *First Avenue* (1957) are also related also to his creation of Lyrical Abstraction. Mathieu's paintings were improvised, quickly produced, highly decorative works. French poet and painter Camille Bryen (1907–1977) was another founder member, along with with sculptor François Stahly (1911–2006), Antoni Tàpies, Hans Hartung (1904–1989), Jean Dubuffet, Wols and members of the CoBrA group (1948–51). The 1950s introduced a second wave of Tachism artists, including Hungarian-born French artist Simon Hantai (1922–2008), Marcelle Loubchansky (1917–1988) and Jean Degottex (1918–1988).

Georges Mathieu, **First Avenue**, 1957, oil on canvas, 152.4 x 152.4 cm
Albright-Knox Art Gallery, Buffalo, NY, USA

1940s–1960s

The New York School is primarily associated with Abstract Expressionism and Action Painting, which emerged in New York City in the 1940s. It defines the art initiative of younger artists living in the city, such as Jackson Pollock (1912–1956) and Robert Motherwell (1915–1991). The tutors, working from their own studios or teaching in American schools of art, were European émigrés, such as Arshile Gorky (1904–48), who settled in the USA in 1920, Hans Hoffmann (1880–1966), who arrived in 1932, and Dutch artist Willem de Kooning (1904–1997), who moved there in 1926. Interest in European art was consolidated in the city by the opening of the Museum of Modern Art in 1929. Interest was primarily in the Surrealist movement, through the influx of Surrealist artists from Europe.

In a 1967 interview Robert Motherwell stated that he had discussed with Chilean artist Roberto Matta (1911–2002) the idea of a group or school of New York Abstract artists to challenge the dominance of Surrealist artists in the city. He wanted to stage a definitive exhibition, like the Armory Show in 1913, to position Abstract art as the art of New York. Many of the artists who had left Germany to escape both the purge of what the Nazis labelled 'degenerate art' and the ensuing war in Europe practised Surrealism. This led Motherwell, Pollock and other artists to establish a congenial group. The New York School was promoted by American art and literary critics, museum and gallery owners in the city, and post-war European tours of contemporary American art. It shifted the centre of the arts world from Paris to the USA, a position that America maintained, in spite of European efforts, until the 1980s.

In his essay 'Avant-garde and Kitsch', published in *Partisan Review* in 1939, the American art critic Clement Greenberg (1909–1994) highlighted the underlying aesthetic, stating that: 'Content is to be dissolved so completely into form that the work of art or literature cannot be reduced in whole or in part to anything not itself.' He actively promoted the contemporary art of Jackson Pollock and Barnett Newman (1905–1970). Aside from Abstract Expressionism and Action Painting, the New York School also encompassed many other abstract art movements, comparable to their counterpart movements in Europe, *Art Informel* and *Tachisme*.

Mark Rothko, **No. 16**, 1949, oil on canvas, 170.9 x 136.9 cm
Private collection

LYRICAL ABSTRACTION

Lyrical Abstraction, a free form of painting, the opposite of geometric abstraction, was at its height in post-war Paris from 1945 to 1956. With its many strands of abstract art associations, it sits under the umbrella of *Art Informel* in Europe and Abstract Expressionism in America. It was founded by two French artists with known links to *Art Informel*: Camille Bryen (1907–1977) and Georges Mathieu (1921–2012), who spoke of his art as *abstraction lyrique*. It was also discussed in terms of *abstraction chaude* (hot abstraction) as opposed to a geometric *abstraction froide* (cold abstraction). Mathieu and Bryen organised the exhibition *L'Imaginaire* at the Galerie du Luxembourg in Paris on 16 December 1947, showing their own works alongside artists whom reviewers identified with 'lyrical abstraction', including Hans Hartung, Hans Arp, Jean-Michel Atlan, Jean-Paul Riopelle and Wols. Their second exhibition, titled *HWPSMTB* – after the first letter of the participating artists': Hartung, Wols, Picabia, Stahly, Mathieu, Tàpies and Bryen – took place at Galerie Colette Allendy, Paris, in 1948. A manifesto accompanied the show.

Mathieu spoke of his highly charged method of painting, which included the free movement of paint, splashed, dripped and spread across the canvas with the rhythm of a dancer. Bryen elaborated on his views in an article for the journal *La Tour de Feu* (1956): 'Painting is the expression of life's deepest manifestations and is organised as a cosmic function. [Not] restricted to sensory emotion, it acts likes magic approaching clairvoyance.' One of the early practitioners of Lyrical Abstraction in America was New York-born Helen Frankenthaler (1928–2011), a follower of Jackson Pollock, who developed her own individual style, with thin paint pigment washes and staining on raw, untreated canvases. Her most defined example is the oil-on-canvas work *Mountains and the Sea* (1952; private collection). Her stain technique informed the Color Field painting movement, notably practised by American artists Morris Louis (1912–1962) and Kenneth Noland (1924–2010). Frankenthaler said of her work: 'The only rule is that there are no rules. Anything is possible.' Abstract works created in the 1950s by New York artists falling into the category of 'lyrical abstraction' include *Dial* (1956), with its surface shimmering with soft light, by Canadian-born Philip Guston (1913–1980).

Helen Frankenthaler, **Mountains and the Sea**, 1952, oil on canvas, 220 x 297.8 cm
Private collection

ABSTRACT EXPRESSIONISM

1940s–1950s

Abstract Expressionism describes American abstract art of the 1940s–50s. The term originated in Berlin in 1919, and was revived around 1929 by Alfred H. Barr, Jr. (1902–1981), first director of the Museum of Modern Art, to describe an abstract work by Wassily Kandinsky. It was reused in 1946 by art critic Robert Coates (1897–1973) in the *New Yorker* magazine to define the expressive, often emotionally charged abstract compositions created in the 1940s by New York-based artists. The movement is linked to *Art Informel* and *Tachisme* in Europe.

Leading proponents of the movement were American artists Jackson Pollock (1912–1956), Robert Motherwell (1915–1991), Barnett Newman (1905–1970) and Franz Kline (1910–1962), along with Russian-born American Mark Rothko (1903–1970) and Dutch-born American artist Willem de Kooning (1904–1997) – all of whom lived in New York City. From the 1930s on, many émigré artists who had moved to the USA from Europe were Surrealist and Expressionist painters who practised automatism, which inspired younger artists in the city. The leading practitioner was Pollock, who arrived in New York in 1930 and studied at the Art Students League under regionalist painter Thomas Hart

Benton. From 1938 to 1942 Pollock took part in the Depression-era work relief programme (Federal Art Project). He followed the art of the Mexican muralists and Pablo Picasso.

Pollock's drip paintings, which define Abstract Expressionism, began in 1947. Placing a vast unstretched canvas on the floor of his studio, he applied household gloss enamel paint in an automatist fashion, diluting it and dribbling it in squiggles and drips, manipulating its position with a stick or paint brush. The wet enamels merged into a puzzle of abstract lines, circles and rivulets. Pollock walked around the floor-canvas to control the flow of paint. His 1948 painting *Number 1. 1948* (later retitled *Number 1A. 1948*) is one of the first canvases he produced by this method. Another notable painter, Robert Motherwell, explored Abstract Expressionism through his interest in philosophy, poetry and history, and followed French poet Stéphane Mallarmé's principle 'to paint not the thing, but the effect it provides'. Motherwell's *Elegy to the Spanish Republic* (1948) forms part of the outstanding *Elegies to the Spanish Republic*, a series of 150 paintings he referred to as 'songs of mourning, elegies – barbaric and severe'.

Robert Motherwell, **Elegy to the Spanish Republic, No. 70**, 1961, oil on canvas, 175.3 × 289.6 cm
The Metropolitan Museum of Art, New York City, NY, USA

Jackson Pollock, **No. 1A, 1948**, 1948, oil and enamel paint on canvas, 172.7 x 264.2 cm
Museum of Modern Art, New York City, NY, USA

COLOR FIELD PAINTING

c.1950–1970

Mark Rothko (1903–1970) and Barnett Newman (1905–1970) were the key proponents of Color Field painting, an American movement and form of Abstract Expressionism. Their creations concentrated on the visual sensation of colour, with large blocks or fields of colour dominating the canvas. In the mid-1940s Newman rejected Surrealism and Expressionism, and challenged the geometric abstraction of Mondrian. He wanted to create a painting that induced a sense of the 'sublime' in the spectator, a mystical, near-spiritual dimension. His method was to use one unbroken pure field, or mass, of colour pigment. He introduced a vertical, or sometimes horizontal band, which he referred to as the 'zip', his signature mark, to accentuate the surrounding colour. Newman saw the small-size, dark red *Onement I* (1948), with its single, vertical, lighter stripe at the centre, as his breakthrough. The later large-scale *Vir Heroicus Sublimis* (1950–51) subverts the 'zip' to accentuate the depth and intensity of the colour. Newman continued to create an astonishing body of color field work throughout his career, an example from the late 1960s being the stunning *White and Hot* (1967).

Rothko abandoned Surrealism in the mid-1940s. A friendship was formed with Clyfford Still (1904–1980), whose innovative experiments with abstract art would later inform Rothko's Color Field painting. His monumental color fields were intended to produce an emotional response. Large-scale dark paintings in deep blue, maroon and plum, or bright yellow, vivid pink and orange were visually stimulating. In the 1950s Rothko's palette darkened in intensity. *Four Darks in Red* (1958) is a vertical field of dense maroon, reds and black. In 1958 he was asked to paint a series of murals for the Four Seasons restaurant in New York's Seagram Building. Nearing completion of the works, he withdrew from the contract. He felt the restaurant setting was not appropriate for his paintings. Seven of the murals now hang in one room in Tate Modern, London. Visitors often find it a spiritual experience. Rothko said of the murals: 'If people want sacred experiences they will find them here. If they want profane experiences they'll find them too. I take no sides.'

Other notable Color Field painters were Still, Morris Louis (1912–1962), Kenneth Noland (1924–2010), Jules Olitski (1922–2007) and Ellsworth Kelly (b. 1923).

Barnett Newman, **White and Hot**, 1967, acrylic on canvas, 213.4 x 182.9 cm
Saint Louis Art Museum, Missouri, USA

AMERICAN MODERNISM

c.1920–1970

Twentieth-century American Modernism can be traced to the formation of the 'Ashcan School' of Robert Henri and his group of 'realist' painters in New York from 1912 on. They aimed to create art that mirrored contemporary life. It is visible in the paintings of artists like Grant Wood (1891–1942), inspired by Flemish Renaissance art. He painted *American Gothic* (1930), to portray Midwest rural values. A view of a different kind was documented in the photography and art of Ben Shahn (1898–1969). His poster *Years of Dust* (1937) was a comment on the chronic poverty of the Great Depression era. He, Dorothea Lange (1895–1965) and Walker Evans (1903–1975) worked for a time for the Resettlement Agency and the government-backed Farm Security Administration. Their documentary photographs highlighted the bleak conditions of rural farming communities.

Stuart Davis (1892–1964), a modernist and realist, studied at the studio of Robert Henri from 1910 to 1913, displaying his watercolours at the 1913 Armory Show. From then on his artwork anticipated movements in contemporary American art. This is visible in *Lucky Strike* (1921), a combination of Synthetic Cubism and commercial packaging that pre-empted Pop Art. It continued in *Deuce* (1954) and *Unfinished Business* (1962). Speaking of his art, Davis said: 'I paint what I see in America ...' His attention to form and structure is characteristic of American Modernism.

Purity of form dominates the art of Georgia O'Keeffe (1887–1986), a pioneer of American Modernism. She held her first solo show in 1917. Her paintings reflect an interest in near abstraction and contemporary life, from *Shelton Hotel, N.Y., No.1* (1926) and *New York Street with Moon* (1925) to detailed, near-abstract flower paintings, as in *The White Calico Flower* (1931). Purity of form was the focus of German-born American artist Josef Albers (1888–1976), who taught at the Bauhaus for ten years. After its closure in 1933 he emigrated to the USA and tutored art at the new Black Mountain College, in North Carolina. He explored the modernist purities of colour and form in hundreds of studies that became his signature series: *Homage to the Square* (1950–76). His style influenced his students Eva Hesse (1936–1970), Robert Rauschenberg (1925–2008) and Kenneth Noland (1924–1991), who went to become renowned artists.

Josef Albers, **Study for Homage to the Square**, 1967, oil on masonite, 101.5 x 101.5 cm
Josef Albers Museum, Bottrop, Germany

ACTION PAINTING

Action Painting, a strand of Abstract Expressionism, was a term created by American art critic and theorist Harold Rosenberg in his article 'The American Action Painters', published in *Art News* in December 1952. His polemic separated the 'action' of painting from the content of the painting. He argued that the methodology of Action Painters, creating art by gesture and instinct in subconscious movements, was as important, perhaps more important than the end result on the canvas. Many critics and artists disagreed but the term was launched. Without naming any contemporary painters in his article, Rosenberg alluded to artists who spilled and dribbled paint, an obvious pointer to Jackson Pollock. The artist, whilst agreeing that he felt intrinsically part of each painting he created while working on it, disagreed that his work involved an element of chance or a subconscious act. He was fully aware of what he wanted to achieve at the outset, controlling the paint as he created his work.

Action Painting, the art of artists who applied paint or substances to their canvases in a violent, gestural method, in the style of Surrealist automatism, was widely practised in New York in the 1940s. One could say that the action is the work of art as much as the finished canvas, with evidence of its creation in the sweeping brushstrokes. Willem de Kooning, moving between figurative and abstract art, painted in a gestural manner, often at speed. This is visible on the canvas in *Woman I* (1950–52) and *Woman and Bicycle* (1952–53), both part of de Kooning's *Woman* series of six paintings. He returned to gestural abstraction around 1955, explored, for example, in *Door to the River* (1960). The art of Franz Kline (1910–1962) exemplifies Action Painting, clearly apparent in the gestural brushstrokes of *Painting Number 2* (1954), and *Mahoning* (1956).

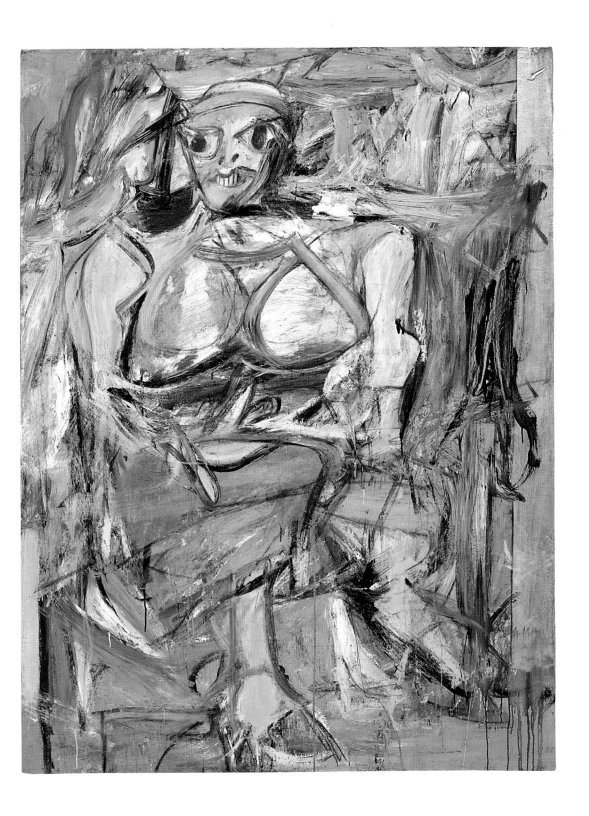

Willem de Kooning, **Woman I**, 1950–52, oil on canvas, 192.7 x 147.3 cm
Museum of Modern Art, New York City, NY, USA

Early
1950s–1970

Pop Art took sprang from two sources, Britain and the USA, taking its inspiration from popular American culture. In Britain, after World War II, American music, films, clothing, cars, and the lifestyle of its celebrities appealed to the younger generation emerging from a period of severe austerity. Established in 1952 in London, The Independent Group embraced Americana and its mass-media culture, and artists moved away from traditional painting taught in British art schools. Included in the group were artists Richard Hamilton (1922–2011) and Eduardo Paolozzi (1924–2005). In 1947 Paolozzi, influenced by Dada and Surrealism, began creating collages from his scrapbooks of American magazine advertisements, including *I was a Rich Man's Plaything* (1947), utilised much later in the *BUNK!* series of screen prints, the first visuals of British Pop Art. In 1956 the Whitechapel Art Gallery in London held an exhibition, *This Is Tomorrow*. Hamilton's collage of US consumer products placed in a modern British home, *Just what is it that makes today's homes so different, so appealing?* (1956), was used as a poster for the exhibition and marked the breakthrough for Pop Art in Britain.

In America the art of Jasper Johns (b. 1930), with his emblematic *Target*, *Flags* and *Number* series, anticipated Pop Art. It referenced American popular culture through the media of movies, television, comics, magazines, advertisements and commercial goods. A postwar generation of young artists, particularly those in New York and Los Angeles, became part of this movement of pop culture – notably Roy Lichtenstein (1923–1997), Andy Warhol (1928–1987), Tom Wesselmann (1931–2004) and James Rosenquist (b. 1933), who were part of the first wave of Pop artists. Lichtenstein appropriated the content of cartoon and comic-strip illustrations, for instance in *Look Mickey* (1961), and *We Rose Up slowly* (1964). His painting *Brushstroke* (1965) is different; it references the Abstract Expressionists, reducing their methods to banal comic-book illustration. Andy Warhol, a commercial artist and print-maker, produced a series of screen prints centred on advertising, celebrity, mass production and mechanical repetition. American Pop Art is defined in such Warhol works as *Campbell's Soup Cans* (1962) and portraits of Marilyn Monroe, Jackie Kennedy, Queen Elizabeth II and Mao Tse-tung.

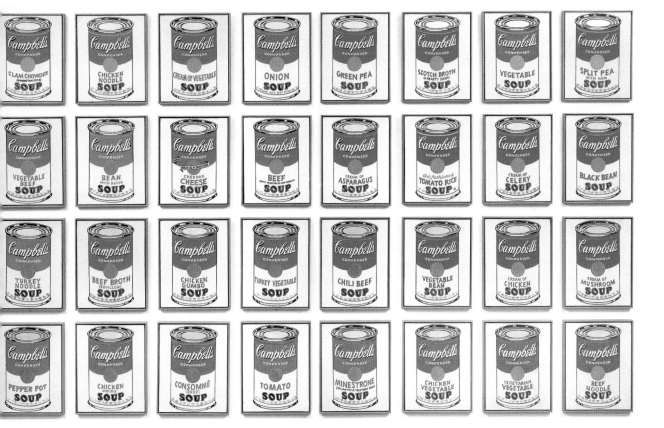

Andy Warhol, **Campbell's Soup Cans**, 1962, screenprint, synthetic polymer paint on 32 canvases, 50.8 x 40.6 cm each
Museum of Modern Art, New York City, NY, USA

Roy Lichtenstein, **Brushstroke,** 1965, colour screenprint, 56.4 x 58.6 cm
Museum of Fine Arts, Boston, Massachusetts, USA

From the 1960s onwards

Op Art (Optical Art), which emerged in the 1960s, was consolidated as an art movement at *The Responsive Eye* exhibition, curated by William Seltz in 1965 at the Museum of Modern Art (MoMA) in New York. The characteristics of Op Art are the use of optical illusion in spiral forms or lines or waves of colour to create the illusion of distance or depth in order to suggest movement. *The Responsive Eye* exhibition included artists Ernst Benkert (1928–2010), Francis R. Hewitt (1936–1992) and Edwin Mieczkowski (b. 1929). All interested in the psychology of perception, they exhibited as the Anonima Group, formed in Ohio in 1960.

In Britain Op Art is intrinsically linked to Bridget Riley (b. 1931) and Michael Kidner (1917–2009), who both exhibited at MoMA in 1965. Riley stands out as one of the first practitioners. Her art concentrates on natural forms – waves, grasses and undulating landscapes – to inform her perception of optical illusion. From 1961 onwards her early black-and-white Op Art paintings, such as *Movement in Squares* (1961), *Blaze 1* (1962) and *Twist* (1963), asserted her presence as an artist – and initiated a fashion craze in Britain and the USA for Op Art patterns, which became a trademark of 1960s' British pop culture. Some critics opined that her early works in black and white were visually aggressive. The introduction of colour from 1966 softened and widened the appeal of Riley's Op Art paintings.

Hungarian-born Victor Vasarely (1906–1997) is fêted as the 'father of Op Art'. His early series of kinetic art, *Gotha* (1959), in twelve serigraphs, explored movement in two-dimensional wave patterns and geometric forms, leading towards Op Art. Other chief exponents are American artist Richard Anuszkiewicz (b. 1930), Polish-born American artist Julian Stanczak (b. 1928) and Japanese-born American painter Larry Poons (b. 1937). All exhibited at MoMA's show in 1965. Stanczak introduced elements of optical art into his work in the late 1950s, putting on a solo show, *Julian Stanczak: Optical Painting*, at the Martha Jackson Gallery in New York in 1964. The title focused on the major element of his work and the growing interest in optical art. It is visible in *Passing Contour* (1962), *Rain and Reflections* (1962) and *Obsession 1* (1965), which explore Stanczak's rhythmic energy, and the exacting formation of linear spacing. Op Art continues as an art movement today.

Bridget Riley, **Movement in Squares,** 1961, tempera on board, 122 x 122 cm
Walker Art Gallery/Arts Council Collection, Liverpool, England

From the 1980s onwards

The art of German painters Anselm Kiefer (b. 1945) and Georg Baselitz (b. 1938) and American artists Julian Schnabel (b. 1951) and David Salle (b. 1952) embodies the core of Neo-Expressionism, which officially emerged in the late 1970s, early 1980s. Other noted artists are from Italy: Francesco Clemente (b. 1952), Enzo Cucchi (b. 1949), Sandro Chia (b. 1946) and Mimmo Paladino (b. 1948), members of Transavanguardia.

In Germany, Neo-Expressionism surfaced in the 1960s in the work of Baselitz and A. R. Penck (b. 1939), amongst others, but attracted little attention. In 1969 Baselitz began depicting his subjects upside down as a way of subverting his signature and emphasising the application of the work rather than the motif itself. The movement was officially launched in early 1980s by a series of exhibitions, in particular the seminal 1981 exhibition *A New Spirit in Painting* at London's Royal Academy. It strongly favoured figurative paintings and brought together the essence of this new movement in its challenge to Minimalism and Conceptual Art. Eleven of the 38 exhibiting artists were from Germany, raising associations with German Expressionism from the years 1905 to 1920.

Neo-Expressionist art and sculpture is generally large in scale. Paint is applied rapidly, often in a rough, gestural manner. Some artists cover the surfaces with other materials to create tension or highlight difference. Artists and sculptors employ a wide range of subjects, which they express as it personally affects or informs them, including history, myth, symbolism, eroticism, religion and contemporary life. Anselm Kiefer, one of the best-known German Neo-Expressionists, works from a diverse field of interests, including philosophy, myth, botany and German history and culture. In his monumental landscapes, which he began producing in 1971, the painting process is clearly defined in the rough application of paint and other media, such as sand, straw, glass, wood, photographs, fabric or barbed wire – as seen in *Your Golden Hair, Margarethe* (1981). The vastness of the canvases makes viewers feel part of the art. Also at the 1981 Royal Academy show was American Neo-Expressionist (now film director) Julian Schnabel (b. 1951). He explored the medium in *The Geography Lesson* (*Huge Wall*) (1980), in oil on velvet, a possible metaphor for cheap, mass-media art.

Georg Baselitz, **The Poet**, 1965, oil on canvas, 162 x 130 cm
On loan to the Hamburger Kunsthalle, Germany

Gerhard Richter, **Abstract Painting**, 1989, CR 707-02 1989, oil on canvas 62 x 82 cm
Collection Barbara and Sorrell Mathes, New York City, NY, USA

1960s

In April 1960, at the Apollinaire Gallery in Milan, French painter Yves Klein (1928–1962) and fellow artists Arman (1928–2005), François Dufrène (1930–1982), Raymond Hains (1926–2005), Jacques Villeglé (b. 1926) and Swiss artist Jean Tinguely (1925–1991) took part in the exhibition *Les Nouveaux Réalistes*. In the preface to the catalogue, French art critic Pierre Restany (1930–2003) referred to 'New Realism'. This was followed by a brief manifesto, *Constitutive Declaration of New Realism*, published on 27 October 1960. It coincided with the formation of 'Nouveau Réalisme', and the Nouveau Réalistes group, which promoted the direct presentation of discarded found objects and threw a spotlight on the waste products of mass consumption. Among those who signed the manifesto were Klein, Romanian-born Swiss artist Daniel Spoerri (b. 1930), Tinguely, Arman, Martial Raysse (b. 1936) and Villeglé.

The event began what was possibly the most important post-war art movement prior to the 1980s. Neo-Dadaist Yves Klein was its leader. Rejecting abstraction, the group looked for the 'gap between art and life' – art that was socially relevant – focusing on real-life experience, mass media and consumption, and using found objects. Klein's route was an experiment with anthropometry art in June 1958, to capture 'states-of-the-moment' flesh. Anthropometrics is a measure of the dimensions of the body and other characteristics. Created in 1961, *Untitled Anthropometry* (*ANT 123*) is one of a series produced using female models as human paintbrushes. In front of an audience, Klein painted models with his trademark International Klein Blue (IKB), which he had registered in 1960, and then dragged them or let them roll across white paper pinned to the wall or the floor to create blue prints. The action caused a sensation, and New Realism was established.

In 1961 Restany organised a New Realist group show, *À 40° au-dessus de Dada* (Forty degrees above Dada), accompanied by a catalogue, at the Galerie J in Paris. In July of the same year the group exhibited at the Galerie Rive Droite in Paris: the exhibition, *Le Nouveau Réalisme à Paris et à New York*, included the American artists Robert Rauschenberg (1925–2008), Jasper Johns (b. 1930), John Chamberlain (1927–2011) and Richard Stankiewicz (1922–1983) – each artist working in his own signature style. New Realism had now become an international movement.

Yves Klein, **Untitled Anthromopetry (ANT 123)**, 1961,
blue pigment and synthetic resin on paper mounted on canvas, 156 x 108 cm
Musée Cantini, Marseille, France

1960s–1970s

Minimal Art emerged in America in the 1960s. Donald Judd (1928–1994), Carl Andre (b. 1935), Dan Flavin (1933–1996), Robert Morris (b. 1931) and Robert Ryman (b. 1930) define its aesthetic. Minimalism reduces sculpture and painting to its purist and most reductive level to reveal the clarity and substance of its form and the space in which it exists. As opposed to Abstract Expressionism, with its existential, impromptu, gestural automatism, Minimalists thought through exactly what each work would express. Simplicity of form, synthesis between size, shape, materials and spatial placement were conceived so as to create a pure form in any chosen medium.

How the term originated is disputed. British writer Richard Wollheim (1923–2003), discussing the all-black canvases of American artist Ad Reinhardt, spoke of 'minimal art' in *Arts Magazine* in 1965. American art critic Barbara Rose (b. 1937), wrote an article on minimalism in the October 1965 issue of *Art in America*. The title of her article, 'ABC Art', referred to what she called minimal art. Her 'ABC' definition did not stick, but her description 'minimal art' did. Rose's close association with many practitioners of minimalist art suggests they agreed on

'minimalism' as a term to embody this new practice. Minimalism is defined in Judd's ongoing series of exact replication of metal cubes. It is also visible in Andre's *Equivalent VIII* (1966) – a rectangular configuration of 120 firebricks that triggered caustic criticism when exhibited – and in the commercial fluorescent light tubes that make up Flavin's *Monument to V. Tatlin* (1966–69), as well as in Morris's *Untitled (L Beams)* (1965) and Ryman's reductive monochrome white paintings, such as *Mayco* (1966).

To focus on one artist, Donald Judd, he started out making his sculptures by hand. The progressive process of his art moved towards large-scale works, and in 1966 he turned to industrial manufacturing, using factory-made cubes and oblongs in metal or plastic to maintain uniformity of size and ensure exact repetition in structure and materials – which removed the artist's hand from the production process. In art circles this challenged Judd's authorship, a throwback argument to Marcel Duchamp's readymade urinal, *Fountain* (1917), but Judd's original plan for the works and the mathematical formulae he devised to retain their uniformity and precision proved he was the originator.

Robert Ryman, **Mayco**, 1966, oil on stretched sized linen canvas, 192 x 192 cm
Daros Collection, Zurich, Switzerland

From 1952 onwards

The first American multimedia 'happening' took place at Black Mountain College, North Carolina, in 1952. It was an unscripted performance with visual art, projection, music, dance and the spoken word orchestrated by experimental composer John Cage (1912–1992). Performing in front of an audience, each participant was allotted a fixed time but otherwise had freedom of presentation. The 'happening' included readings by Cage and others, dance by choreographer Merce Cunningham (1909–2009) and a display of four 'white' paintings by Robert Rauschenberg (1925–2008). That 'happening', untitled when it was originally performed, is now known as *Theatre Piece, No. I.* (1952). It marks the moment when performance art, or a 'happening', became part of visual art.

In Europe, performance art in the modern era has noteworthy origins in the German Bauhaus school (1919–33), where staged performances were part of the arts curriculum. For Futurists and Dadaists, performance of poetry, music, dance and staged plays were integral to their movements' aesthetic. In 1958 Yves Klein's 'anthropometric' painting sessions (see Nouveau Réalisme) took place before an invited audience. The

German artist Joseph Beuys (1921–1986) saw his life as a *gesamtkunstwerk* (total artwork). In November 1965 he performed *How to Explain Pictures to a Dead Hare*, carrying a dead hare from picture to picture to consider the complexity of ideas. In one of his most celebrated performances, *I Like America and America Likes Me* (May 1974), he spent several days days in a room at the René Block Gallery in New York with a wild coyote, a symbol of Native America. In Britain, artists Gilbert and George – Italian-born Gilbert Proesch (b. 1943) and Englishman George Passmore (b. 1942) – presented themselves as living sculptures. In *The Singing Sculpture* (1969) they performed the music-hall song 'Underneath the Arches' for five hours while standing on a table. Proesch stated that 'To make art you don't need objects, you just need yourself as the object.'

American experimental performance artist and musician Laura Anderson (b. 1947) uses multimedia technology and electronic sound in her presentations. Her filmed recording of her eight-minute hit single 'O Superman' (1981) gave her mass-media status beyond the arts world and global recognition for performance art.

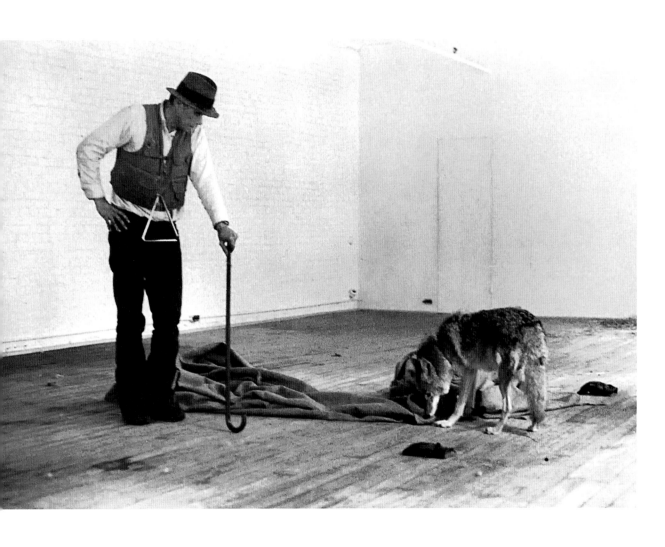

Joseph Beuys, **I Like America and America Likes Me**, Galerie René Block,
New York. May 1974. Photograph by Caroline Tisdall

c.1960–1990

The chief motivator behind Fluxus, a Dada-inspired, informal group of anti-art artists, primarily from Germany and the USA, was George Maciunas (1931–1978), a Lithuanian-born American artist. In the 1960s and 1970s they incorporated diverse art forms, sound, video, music, performance and events, including Flux festivals, to bring together 'art and life' through a wide range of artistic creations and concepts. Maciunas claimed that 'Anything can be art and anyone can do it.' Major influences included Duchamp's concept of the readymade, John Cage's concrete music, the performance art of dancer Merce Cunningham and the Nouveaux Réalistes. Chief among artists associated with Fluxus are Maciunas, Nam June Paik (1932–2006), Wolf Vostell (1932–98), Dick Higgins (1938–1998), Yoko Ono (b. 1933), Joseph Beuys and Alison Knowles (b. 1933).

The first Fluxus Festival, held in Wiesbaden, Germany, in 1962, was organised by Maciunas while he was working there as a graphic designer for the US military. Following this, in 1963, he issued a brief manifesto to draw together the purpose of Fluxus. His text included a plan 'to purge the world of bourgeois sickness, "intellectual",

professional and commercialised culture, purge the world of dead art, imitation, artificial art, abstract art, illusionistic art, mathematical art – purge the world of Europanism!' [sic] Promote a revolutionary flood and tide in art. Promote living art, anti-art ...'

Korean-born American artist Nam June Paik was a musician and perform-ance artist, and a proponent of video art. In live performances he often destroyed his objects, such as a violin in *One for Violin Solo* (1962). He created robots from television sets, stating that 'Television has been attacking us all our lives, now we can attack it back' – *Hi-Tech Baby* (1986) and *Powel Crosley Jr.* (1992) are two examples. German-born Wolf Vostell (1932–1998) was a leading Fluxus partici-pant, a pioneer of video art, and possibly the first to include a television set in a work of art. In his own 27-line mani-festo, issued in 1963, each four to five-word line began with the word 'Décol-lage', suggesting the tearing apart and deconstruction of objects such as billboards, which informed some of his work, including *Coca-Cola* (1961).

Nam June Paik, **Hi-Tech Baby**, 1986,
13 colour TV sets, aluminium framework, TV cabinet screen, acrylic paint, videodisc and player, 203 x 108 x 51cm
Private collection

VIENNESE ACTIONISM

From the 1960s onwards

Wiener Aktionsgruppe, or the 'Vienna Action Group' of radical art, film and performance, emerged in the 1960s. Viennese Actionism stands out for its violent, obscene, quasi-brutal enactments or 'Actions', which were intended to confront repressed cravings. The group of painters would use paint mixed with bodily fluids, food or rags to create works in a fast, expressive format. Today Viennese Actionism is remembered for the 'Action' performances generated during their art productions. Founders of the group were Otto Muehl (1925–2013), Hermann Nitsch (b. 1938), Günter Brus (b. 1938) and Rudolf Schwarzkogler (1940–1969).

Up until the mid-1970s the groups' Actions were recorded in photography by Ludwig Hoffenreich (1902–1975). Brus gained attention for his non-violent *Wiener Spaziergang* (1965) or 'Vienna walk'. Having painted himself and his suit white, and with a black stripe down his head, face, body, one leg and up the back of his suit to his head again, he walked around the Austrian capital as a 'living picture'. This first non-violent performance in a public space resulted in police intervention and a fine. At Schwarzkogler's first performance, *Wedding* (1965), three photographers. documented his self-

styled rituals during his dissection of a fish and a chicken, performed on a white-clothed table in front of friends. The artist found the presence of an audience uncomfortable, and his subsequent Actions were generally seen only by the photographers who recorded them.

The group became notorious for its many shock-value events, intended as a socio-political response to what they saw as a complacent post-war, post-Fascist society in Austria. Their performances, involving acts of bloodied body-rituals, violence and indecency, often ended in police raids and lots of publicity. On 28 June 1963, with a shocked audience looking on, police raided a basement studio in Perinetgasse, where a performance involving a naked woman, marmalade and flour was due to take place as part of the 'Festival of Psycho-Physical Naturalism'. Muehl's Action *Cosinus Alpha* (1964) used bodies as his material to depict primitive sexual behaviour. Kurt Kren (1929–1998) later based a silent nine-minute colour film on this Action. In the 1980s Nitsch planned an underground complex based on the interior of the human body, shown in his 1967 series *Untitled* (*The Architecture of the Orgies Mysteries Theatre*).

Hermann Nitsch, **Untitled**, from the series 'The Architecture of the Orgies Mysteries Theatre', 1967,
lithograph with coloured crayons on paper, 107 x 80.3 cm
Saint Louis Art Museum, Missouri, USA

PHOTOREALISM AND HYPERREALISM

<div style="text-align:right">

From the late 1960s onwards

</div>

In Photorealism and Hyperrealism (also known as Superrealism), artists create illusionistic images of reality with their paintings and sculptures. It is exemplified in the early work of American artist Chuck Close (b. 1940), for which he used a black-and-white palette, in the acrylic on canvas *Self-Portrait* (1968), and *Frank* (1969). His method involves printing out a photograph and overlaying it with a grid system in order to be able to replicate each grid square when magnified on a large-scale canvas. He replicates the original image using acrylic paint and an airbrush to avoid the presence of brush-strokes on the surface. Close makes no claim to be a purist and does not aim for 100 per cent accuracy. Nevertheless, the realism of his art makes it difficult to assimilate what one is looking at and there is a constant urge to see how he recreates a photograph with paint. After 1970 Close turned to colour, creating a tapestry of paint colours in the squares (an effect similar to that pointillism), where the intended illusion of a photograph – such as in *Agnes* (1998) – is best achieved when viewed from a distance.

Richard Estes (b. 1932) specialises in hyperreal scenes of the urban New York City landscape, usually devoid of people, leaving the viewer to focus on the buildings, streets, spaces. His reflective surfaces heighten the sense of reality, as in *Telephone Booths* (1967). From 1960 on he began to photograph each cityscape as a record before reproducing it on a large-scale canvas. His technique reveals more in the painting than the naked eye could capture in a street view. *The Canadian Club, New York* (1974) and *Central Savings* (1975) are examples from the 1970s. Estes's city repertoire moved to Europe in the 1980s, for example *Salzburg Cathedral* (1981). He introduced seascapes in the 1990s, such as *Water Taxi, Mount Desert* (1999).

Two of the masters of hyperrealism in sculpture are American artist Duane Hanson (1925–1996) and Australian sculptor Ron Mueck (b. 1958). Hanson has created life-cast sculptures since the 1970s to explore human character types of middle America. It is the ordinariness of his characters, portrayed in *Supermarket Lady* (1970), *Museum Guard* (1975) and *Tourists II* (1988), that makes his sculptures so remarkable. Mueck, who works from a maquette, came to attention with a half life-size figure, *Dead Dad*, created in 1996/97 and shown at the *Sensation* exhibition in London in 1997.

Chuck Close, **Frank**, 1969, acrylic on gessoed canvas, 274.3 x 213.4 cm
Minneapolis Institute of Arts, Minneapolis, USA

From the late 1960s onwards

The term 'Arte Povera' (or poor art) was coined by Italian curator and art critic Germano Celant (b. 1940) in 1967 for a two-section exhibition, *Arte Povera – IM Spazio*, held at the Galleria La Bertesca in Genoa, Italy. Celant used the term to describe the works of artists – many of whom had moved away from painting – that incorporated readily available, natural, non-natural, non-precious and non-artistic materials. These were often cheap or discarded resources such as textiles, glass, newspapers, stones, wood, iron and coal. Arte Povera artists saw their work as a reaction to the material excesses of consumer capitalism of the 1960s. The artists exhibiting in the *Arte Povera* section of the Genoa show were Alighiero Boetti (1940–1994), Luciano Fabro (1936–2007), Jannis Kounellis (b. 1936, Piraeus, Greece), Giulio Paolini (b. 1940), Pino Pascali (1935–1968) and Emilio Prini (b. 1943). Like the works shown in the *Arte Povera* section of the show, those on display in the *IM Spazio* (imagined space) section also aimed to look at art in relation to the spatial structure of the gallery.

Mario Merz (1925–2003), one of the foremost artists of the Arte Povera movement, looked closely at the geometry of art and the natural world, particularly the relationship between structure and space. His interest in the Fibonacci sequence – in which each number is equal to the sum of the two preceding it – and its natural occurrence in nature is evident in his *Spiral* and *Igloo* series, as in the mixed-media *What Is to Be Done?* (1969). His last work, a site-specific installation exhibited in the Imperial Forum in Rome in 2003, were spirals of bright neon tubing, two favourite constituents of his work, each relating to the surrounding structures and open space so as to create a mystical experience.

The most intense period for Arte Povera was from the late 1960s to early 1970s. It continues today in the works of Kounellis, Prini and Paolini, and others closely linked to the original group, such as Michelangelo Pistoletto (b. 1933). At the forefront is the provocative Santiago Sierra (b. 1966, Madrid), whose controversial installations, performances and political references are in the tradition of the group's fundamental ideology.

Mario Merz, **What Is to Be Done?**, 1969,
mixed media Reinstallation, 9 February – 9 December 2012,
at the CAPC Musée d'Art Contemporain, Bordeaux, France

From the 1980s onwards

The art-world buzzword of the 1980s was 'appropriation art', the intentional copying of an image or object, with minimal alteration. Appropriating was not stealing if it acknowledged the original work. German artist Gerhard Richter's (b. 1932) fascination with the Red Army Faction led to his 1988 series of paintings *18 October 1977*, based on photos of dead members of the Baader-Meinhof terrorist group.

As a concept it has reverberated throughout the history of art. Focusing on the early 20th century, it surfaced in the 'readymades' of French Surrealist and Dada member Marcel Duchamp (1887–1968), such as *Bicycle Wheel* (1913), *Bottle Rack* (1914) and a urinal, *Fountain* (1917). Duchamp opened debate on what art is by asserting that everyday objects were art if he said as much. A German pioneer of photomontage, John Heart-field (1891–1968), a member of Berlin's Dada group, appropriated photographs of political leaders to create mocking montages, such as *Adolf the Superman Swallows Gold and Spouts Junk* (circa 1932). The Pop Art era of the 1960s exploded with new forms of appropria-tion. American artist Andy Warhol's *Brillo Box* (1964) is a plywood copy of a card-board Brillo box. In *Twenty-Five Colored Marilyns* (1962) he reduced celebrity to banality by painting multi-images of the star over copies of the original photo. Roy Lichtenstein's use of enlarged Ben-Day dots for his comic-strip paintings appropriated comic-book illustrations, magnifying them to a new art form.

American artist Barbara Kruger (b. 1945) juxtaposes words with appropri-ated images often taken from advertise-ments of the 1940s and 1950s. The result is disconcerting, exposing the use of women as objects, as in *Untitled* (*Your Comfort Is My Silence*) (1981) and *Untitled* (*Your Gaze Hits the Side of My Face*) (1981–83). American painter, photogra-pher and pioneer of appropriation art Richard Prince (b. 1949) has often courted controversy in his valuation of authorship and ownership. *Spiritual America* (1983), a rephotographed image of actress Brooke Shields, shows her naked, aged ten. The original 1975 photo, by American photographer Gary Gross, was taken for a soft-porn magazine with her mother's consent. It was removed from a 2009 Tate Modern exhibition after Scotland Yard warned that it could violate obscenity laws.

Barbara Kruger, **Untitled (Your Gaze Hits the Side of My Face),** 140 cm x 104 cm, photograph, 1981
Mary Boone Gallery, New York, NY, USA

From the 1960s onwards

Lowbrow deliberately distances itself from high art and is also labelled Kustom Kulture, Comic Surrealism, Cartoon Expressionism and Pop Surrealism. Its innovators were Kenny 'Von Dutch' Howard (1929–1992) and Ed 'Big Daddy' Roth (1932–2001). It surfaced in the 1960s as Californian custom-car art and led to the publication of 'underground comix', pioneered by Roth. Lowbrow art is indelibly linked to the work of Robert Williams (b. 1943), who began as a commercial artist for Roth. In 1968 Williams joined San Francisco-based *Zap Comix* as an illustrator.

'Underground comix' included visual content that was banned by the Comics Code Authority – primarily drug use, violence and sex. Back then San Francisco was the centre of the 'flower power' movement, which began as a peaceful protest group against US involvement in the Vietnam War. In 1967 thousands of 'hippies' flocked to the city's Haight-Ashbury district, where 'free love', music and drugs were all part of the now legendary 'Summer of Love'. Psychedelia, fuelled by an intake of illicit drugs, notably LSD, created an art form that was particularly visible on tie-dyed T-shirts, posters, album covers and music maga-

zines, and which recreated the 'colour-drenched' out-of-body experience of mind-bending substances. It was in this environment that *Zap Comix* operated.

Williams and others used that energy and freedom to produce shocking, cartoon-style images for adults, including custom-car pin-striping art, for which writer Tom Wolfe called him 'the Salvador Dalí of the hot-rod movement'. In the late 1970s Williams was part of a Los Angeles art group, 'Art Boys', which included included Matt Groening (b. 1954) and Mike Kelley (1954–2012). Williams's painting *Appetite for Destruction* (1978) – became the cover illustration for the 1987 debut studio album of the same name by Guns N' Roses – increased his presence in the arts world. In 1994, in response to the culture of abstract and minimalist art, he launched the art and culture magazine *Juxtapoz*, a mix of figurative psychedelia, Surrealism and Pop art, to promote artists working in the 'lowbrow' genre.

Other notable Lowbrow artists include Robert Crumb (b. 1943), Victor Moscoso (b. 1936), Manuel 'Spain' Rodriguez (1940–2012), Gilbert Shelton (b. 1940), S. Clay Wilson (b. 1941) and Rick Griffin (1944–1991).

Robert Williams, **Hot Rod Race**, 1976, acrylic on board, 32.38 x 41.27 cm
Location unknown

From the 1980s onwards

Neue Wilde (new wild ones) was coined by Wolfgang Becker (b. 1936) – founding director (1970–2001) of the Neue Galerie – Sammlung Ludwig in Aachen (renamed the Ludwig Forum für Internationale Kunst in 1991) – for an exhibition held there in 1980. The name is evocative of the early 20th-century Fauves (wild beasts) and is used to distinguish the style from Neo-Expressionism. It is also referred to as *Junge Wilde*, 'New Wild', 'New Image Painting' or 'Wild-Style', *Figuration Libre* (spontaneous figurative painting). The term describes a vigorous, freestyle of painting known as *heftige Malerei* (vigorous, violent, fierce painting), with indicative links back to Expressionism. Forerunners of the Neue Wilde were A. R. Penck (b. 1939), Georg Baselitz (b. 1938), Jörg Immendorff (1945–2007) and Markus Lüpertz (b. 1941).

The term took on its actual significance with a younger generation of mainly German artists centred around Rainer Fetting (b. 1949), Helmut Middendorf, (b. 1953), Salomé, (b. 1953) and Bernd Zimmer (b. 1948). They created the 'Selbsthilfegalerie' (self-help gallery) in 1977, at the Galerie am Moritsplatz, near the Berlin Wall. A show of their work in the exhibition *Heftige Malerei* at Haus am Waldsee in Berlin in 1980 brought recognition. Many in the New Image group, notably Stefan Szczesny (b. 1951), perceived their art as a challenge to abstraction, minimalism and conceptual art. Szczesny wanted to shift the language of the group's art closer to the rock music of their generation.

Each of the Berlin four had a different approach but all preferred vast canvases. Fetting's were usually more than two metres high. His intense colour palette is reminiscent of the paintings of Vincent van Gogh. He uses various media, including charcoal, oils and watercolour, often within a single painting. Fetting's subjects vary from city scenes to erotic nudes. *Mann u Axt – Frau I* (1980) in acrylic on canvas is one of a series featuring a naked man with an axe. The artist creates a disconcerting scenario in which a naked man, his back to the viewer, looks towards a heavy axe on the floor. A clothed woman standing to his right stares out at the viewer. The neon-like colours are acidly sharp and parts of the canvas are smeared with an overlay of paint. Fetting offers no clues as to what will happen next, leaving the viewer to draw his own conclusions.

Rainer Fetting, **Mann u Axt - Frau I**, 1980, dispersion on canvas, 200 x 200 cm
Private collection

YOUNG BRITISH ARTISTS

From the late 1980s onwards

In the late 1980s a new generation of British artists emerged, collectively labelled 'Young British Artists' (YBAs) by arts writer and lecturer Michael Corris in his article 'British? Young? Invisible? w/Attitude?' in *Artforum* (May 1992). The artists had met through their art studies at London University's Goldsmiths College. Key members were Damien Hirst (b. 1965), Sarah Lucas (b. 1962), Gary Hume (b. 1962), Anya Gallaccio (b. 1963) and Michael Landy (b. 1963). Their first collective student-run show, *Freeze*, was organised by Hirst in his second year at the college. Three rolling exhibitions were held in 1988 in an empty London Port Authority gymnasium building in Surrey Docks, south-east London.

Hirst personally invited the artists he wanted. The large YBA group was formed by Lucas, Hume, Landy, Gallaccio, Steven Adamson, Angela Bulloch (b. 1966), Mat Collishaw (b. 1966), Ian Davenport (b. 1966), Angus Fairhurst (1966–2008), Abigail Lane (b. 1967), Lala Meredith-Vula (b. 1966, Sarajevo), Richard Patterson (1963), Simon Patterson (b. 1967), Stephen Park (1962) and Fiona Rae (b. 1963). It was here that Hirst first exhibited his spot paintings, which he painted directly onto the gymnasium walls. A later example is *Controlled Substances Key Painting 3" Spot* (1994).

Artist Michael Craig-Martin, one of their tutors at Goldsmiths, alerted galleries and collectors to the exhibition. However, as Hirst commented in January 1992, '*Freeze* is the kind of exhibition that everyone said they saw and hardly anybody did.' Further group shows followed and artist numbers increased. Those associated with the YBA tag include Tracey Emin (b. 1963), Chris Ofili (b. 1968), Sam Taylor-Wood (b. 1967), Jake and Dinos Chapman (b. 1966 and 1962), Jenny Saville (b. 1970), Rachel Whiteread (b. 1963) and Gavin Turk (b. 1967).

From the outset at *Freeze*, artworks were bought by the British collector Charles Saatchi (b. 1943). In 1997 his collection of contemporary art was put on display at the *Sensation* exhibition at London's Royal Academy, showing 110 works by 42 artists. It was a defining moment for the YBAs, giving them global exposure. Works that sum up the YBAs include Sarah Lucas's sculpture *Pauline Bunny* (1997) and Hirst's famous pre-served shark, *The Physical Impossibility of Death in the Mind of Someone Living* (1991).

Sarah Lucas, **Pauline Bunny,** 1997, tan tights, black stockings, chair, clamp, kapok, wire, 103 x 89 x 79 cm
Sadie Coles HQ, London, England

From the late 1980s onwards

The rise in fame of the 'New Leipzig School' is inherently linked to the demise of communist rule in East Germany after the fall of the Berlin Wall on 9 November 1989. The subsequent reunification of Germany exposed the art of East Germany to a global audience. For the 28 years since the Berlin Wall's construction on 13 August 1961, tutors and students at the Leipzig Academy of Visual Arts had been shut off from Western avant-garde art. The academy's tutors concentrated on traditional figurative drawing and painting. Associated with the school were artists from the pre-Wall era, notably Bernhard Heisig (1925–2011), Wolfgang Mattheuer (1927–2004) and Werner Tübke (1929–2004). After reunification, the Leipzig academy embraced new media, and figurative painting was for a time demoted but later restored to equal other art forms taught there.

Since Germany's reunion, Leipzig has come to prominence for its 'school' of figurative painters, most notable in the art of Leipzig-born Neo Rauch (b. 1960) – he studied for his MA under Heisig's mentorship and was a rising artist just prior to 1989. Rauch became a professor of painting at the Academy in 2005.

Younger artists followed on from him. Tilo Baumgärtel (b. 1972), Peter Busch (b. 1971), Tim Eitel (b. 1971), Christoph Ruckhäberle (b. 1972), David Schnell (b. 1971), Matthias Weischer (b. 1973) and Julia Schmidt (b. 1976) have enjoyed a dramatic rise to fame through global interest in their art. In some respects this is due to the promotion of Leipzig Academy artists since the late 1980s by art dealer Harry Lybke's Galerie Eigen+Art in Leipzig and Berlin.

Neo Rauch paints disconcerting figurative compositions in a surreal-realist manner. *Self in Studio* (1985, part of his graduation work from Leipzig academy in 1986 brought recognition of his talent. *Ohne Titel* (1987) was exhibited the following year. It gained him a wider audience and spotlighted painters at the academy. Although Rauch does not allow his pre-1993 works to be shown, in order to focus attention on his artworks created after that date, such as *Nacht-arbeit* (1997; Night Work), they can still be found in early catalogues and books.

Neo Rauch, **Nachtarbeit** (Night Work), 1997, oil on canvas, 200 x 320 cm
Galerie Neue Meister, Dresden, Germany

GLOSSARY

GLOSSARY

ABSTRACT, ABSTRACT ART, ABSTRACT PAINTING

Abstract means 'non-representational'. A non-representational movement in art began in 1910. Artists were interested in allowing forms and colours to work in their own right, rather in than depicting things.

ACTION

An action, performance or happening is like an experimental theatrical or musical production. In contrast to works of art in museums, an event, or happening, takes place only in the here and now. Happenings and performances draw the viewers into the action, but an action can also take place without an audience and be viewed later (for example, in photographs).

THE ARMORY SHOW

From 17 February to 15 March 1913, the "International Exhibition of Modern Art" was held in New York City's 69th Regiment Armory. Organised by the Association of American Painters and Sculptors, the exhibition introduced American audiences to avant-garde Modernist art by hundreds of European and American artists, including examples of Cubism, Fauvism, and Post-Impressionism. The show stunned viewers and critics, some of whom ridiculed bold statements in form such as Marcel Duchamp's *Nude Descending a Staircase, No. 2* (1912). Despite a mixed critical reception, the show inspired many American artists to begin to experiment with Modernism.

AVANT-GARDE

The avant-garde, as precursors of a new idea or movement, anticipate a general development, break with traditional forms and establish something radically new.

COLLAGE

(From the French *coller*: to glue) This artistic technique creates pictures by gluing together newspaper cuttings, scraps of fabric, wallpaper, cut-up images, etc.

CONTEMPORARY ART

Art produced by living artists and regarded as important by other contemporaries. Generally it means present-day art. The term modern art is not the same, as it may include art from the early 1900s onwards, i.e. the historical phenomenon known as Modernism, and does not therefore necessarily mean contemporary or up-to-date. The terms contemporary art and present-day art say nothing about a work's concept, artistic style, technique, form or adhesion to any particular artistic movement or group.

CONCEPTUAL ART

'Conceptual art' has become a blanket term for art in which the idea behind the work is more important than the material product. This notion has its roots in the 'readymades' of Marcel Duchamp, but it was not until the late 1960s that the philosophy developed into a large-scale movement, within which artists began rethinking traditional aesthetic concerns. In some cases they eliminated the physical art object altogether. Joseph Kosuth's landmark work *One and Three Chairs* (1965) invited the viewer to consider the notion of 'chairness' through an installation that consisted of a physical chair, a photograph of a chair and a written definition of the word 'chair'. Such works repudiated the conventional formal element of art and directed the viewer's attention to its concept, giving the idea priority over the object.

FINE ART

Art appealing to the sense of beauty, especially painting and sculpture. Nowadays, the term embraces all forms of artistic practice, and therefore includes photography, film, architecture and design.

GRAPHIC ART

(From the Greek *graphein*: to write, draw, scratch) Graphic art includes drawing or the result of a technical printing procedure (printed graphics), for example an etching, a woodcut, a copperplate engraving, a lithograph or a screen print.

HAPPENING → ACTION

INSTALLATION

Installations are three-dimensional works of art set up in an existing space. They can use a great variety of materials and media.

MODERN ART

Collective term for the various art styles since about 1890.

OBJECT

Objects are (modern) works of art made of, or assembled from, found objects.

OBJECT ART → CONCEPTUAL ART

PERFORMANCE → ACTION

PORTRAIT, PORTRAITIST

(From the Latin *portrahere*: to draw forth)

Portraits depict particular people. A distinction is made between single, double and group portraits. They can show the whole (full figure) or part of a person (head, head and shoulders, half-figure, three-quarter figure) from the front (front view, en face) or from the side (profile). Commissioned portraits are ordered from the painter. A self-portrait depicts the artist himself.

PUBLIC ART

A collective term for works of art of any period or style displayed in publicly owned spaces such as city parks, streets or squares. They may range from equestrian statues from antiquity, through Gaudí's Parc Güell in Barcelona or Niki de Saint Phalle's *Nana* figures in Hanover dating from the 70s. The stencilled graffiti of British street artist Banksy also counts as public art. One of the best-known works of art in a public space is Christo and Jeanne-Claude's wrapping of the Reichstag in Berlin in 1995.

RETROSPECTIVE

A retrospective – literally: looking back – is an art exhibition that sums up individual phases of an artist's work, or all of it.

SCULPTURE

Sculptures are three-dimensional works of art. A distinction can be made between a work of art created from a malleable material that was originally soft (for example, clay), or carved from a hard material (stone, wood). A free-standing sculpture is a work of art that can be viewed from all sides.

SERIES, ALSO EDITION

In fine art, this means a series of works of art of the same kind.

VIDEO ART

A form of art that makes use of projection as the medium of artistic statement. Video art was born in Germany and America in the early 1960s. Artists use video techniques, i.e. present videos as part of a video installation or in the form of a video sculpture. The technique itself may be part of the subject matter and the screen is regarded as a new 'canvas' that opens up new opportunities and forms of painting with moving pictures. Leading video artists are Nam June Paik, Bill Viola, Gary Hill and Nan Hoover.

PHOTO CREDITS

The illustrations in this publication have been kindly provided by the museums, institutions and archives mentioned in the captions, or taken from the publisher's archives, with the exception of the following: akg-images/Erich Lessing: 25, 35, 65; Archive Ida Chagall, Paris: 67; Artothek: 56/57; Atelier Richter: cover, 110/111; © Bildarchiv Preußischer Kulturbesitz/Art Ressource, New York/Jörg P. Anders: 77; The Bridgeman Art Library: 28/29, 41, 42/43, 47, 53, 59, 61, 79, 81, 85, 87, 89, 97, 113, 119, 121; BÜRO + ARCHIV GEORG BASELITZ/Frank Oleski, Cologne: 109; CAPC Musee d'Art Contemporain, Bordeaux, France/Frédéric Deval, Mairie de Bordeaux: 125; Cleveland Museum of Art, Ohio, USA: 63; Courtesy Chuck Close and Pace Gallery: 123; Rainer Fetting/© Jochen Littkemann: 131; Marianne Franke, Munich: 37, 69; Galerie René Block, New York/Caroline Tisdall: 117; Gemäldegalerie, Neue Meister, Dresden: 135; Josef Albers Museum Bottrop: 99; Kunsthalle Tübingen: 20; © Sarah Lucas, courtesy Sadie Coles HQ, London: 133; Joseph S. Martin/Artothek: 31; Courtesy Mary Boone Gallery, New York: 127; Menil Collection, Houston, TX, USA/Giraudon/The Bridgeman Art Library: 55; Metro Pictures, New York: 21; The Museum of Modern Art, New York/Scala, Florence: 94/95, 101, 103; Southampton City Art Gallery (lender): 75; Tretyakov Gallery, Moscow: 17; Wien Museum, Vienna: 83; Peter Willi/Artothek: 27

Cover: Gerhard Richter, *Abstract Painting*, 1989, CR 707-02, see p. 110/111

Prestel Verlag, Munich
A member of Verlagsgruppe Random House GmbH

Prestel Verlag
Neumarkter Strasse 28
81673 Munich
Tel. +49 (0)89 4136-0
Fax +49 (0)89 4136-2335

Prestel Publishing Ltd.
14–17 Wells Street
London W1T 3PD
Tel. +44 (0)20 7323-5004
Fax + 44 (0)20 7323-0271

Prestel Publishing
900 Broadway, Suite 603
New York, NY 10003
Tel. +1 (212) 995-2720
Fax +1 (212) 995-2733

www.prestel.com

Library of Congress Control Number: 2014930621; British Library Cataloguing-in-Publication Data: a catalogue record for this book is available from the British Library; Deutsche Nationalbibliothek holds a record of this publication in the Deutsche Nationalbibliografie; detailed bibliographical data can be found online at: http://www.dnb.de
Prestel books are available worldwide. Please contact your nearest bookseller or one of the above addresses for information concerning your local distributor.

Editorial direction: Claudia Stäuble
Project management: Dorothea Bethke
Copy-editing: Danko Szabó, Munich
Layout: Mogwitz Design, Munich
Production: Astrid Wedemeyer
Separations: Reproline Mediateam, Munich
Printing and binding: Druckerei Uhl GmbH & Co. KG, Radolfzell

Verlagsgruppe Random House FSC® N001967
The FSC®-certified paper *Hello Fat Matt* is produced by mill Condat, Le Lardin Saint-Lazare, France.

ISBN 978-3-7913-4880-3